THE SPIRIT OF THE PLACE

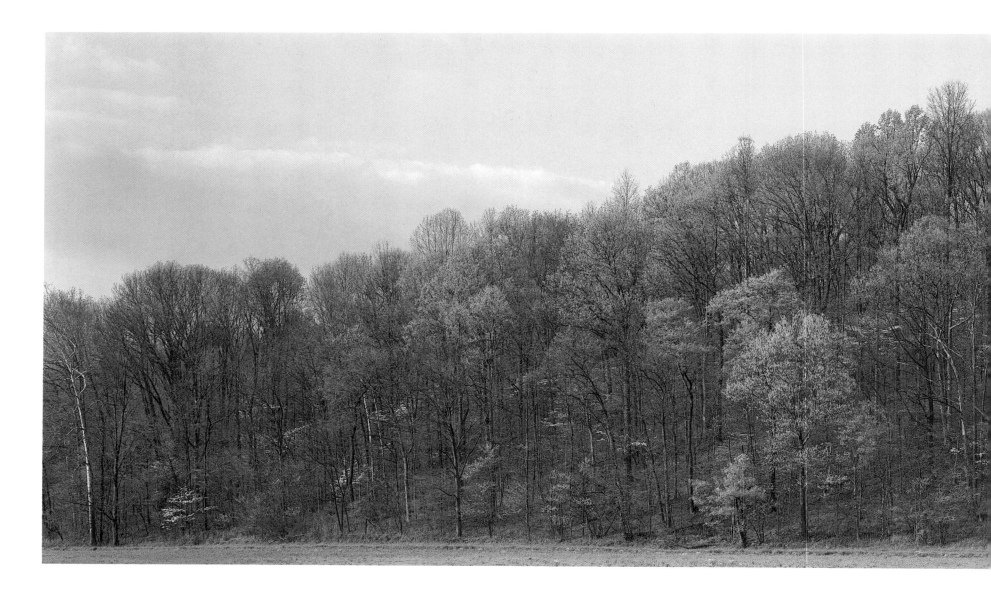

THE SPIRIT

Indiana Hill Country

Indiana University Press Bloomington & Indianapolis

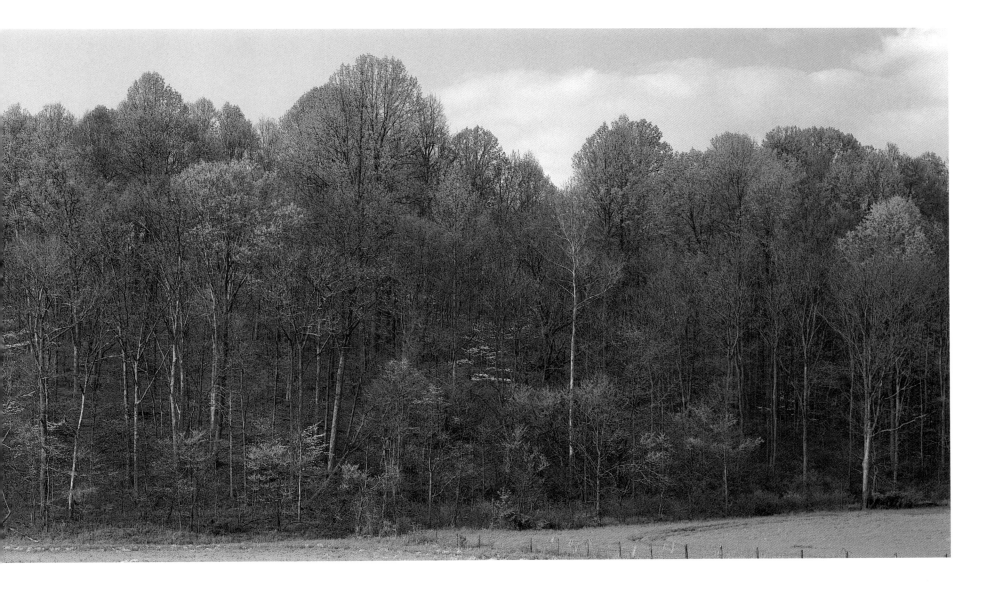

O F T H E P L A C E

PHOTOGRAPHS BY Darryl Jones

TEXT BY James Alexander Thom

The paper used in this publication meets the minimum requirements of American
National Standard for Information Sciences—Permanence of Paper for Printed
Library Materials, ANSI Z39.48-1984.

Printed in Singapore

Cataloging Data

Jones, Darryl
The spirit of the place : Indiana hill country / photographs by Darryl Jones ; text by
James Alexander Thom.
 p. cm.
ISBN 0-253-32987-6 (alk. paper)
1. Indiana—Description and travel. 2. Indiana—Pictorial works.
I. Thom, James Alexander. II. Title.
F532.A16J16 1995
779'.991772—dc20 95-16713

1 2 3 4 5 00 99 98 97 96 95

Photographer's Preface

My interest in photographic landscapes has continued throughout a thirty-year period. From 1960 to 1963 I used a box camera, a Brownie "Star Mite," to record the countryside during family trips to the American West. The first panoramic images that I produced were sequences of photographs that I had taken in the Badlands of South Dakota, carefully cut apart and taped back together. This was a precursor to the type of work that I am doing now with long, panoramic photographic images.

As I became older the scenes became more refined, depicting elements of design, beauty, and harmony. I was inspired by the long horizontal images of Chinese landscape paintings. When I was a senior in high school, I built a device for a 35mm camera that would center the lens directly over the pivotal point of a tripod. This allowed the edges of a sequence of images to be aligned accurately to produce a complete 360° photograph. These would be printed and taped together to form one long panoramic image.

During high school I was very attracted to the writings of Thoreau and Emerson.

These writers provided my first insight into the transcendental elements of nature. Their language was highly visual–they could "see" in nature deeper meanings. Inspired and intrigued by their words, I set off to express with images what they expressed in words.

This interest continued after graduating from high school when I went on a student trip to Norway and Denmark as a delegate to the 1966 YMCA World Youth Conference. This first trip to Europe introduced me to the fjords and mountains of Norway and to Scandinavian landscapes. A second trip to Europe in the summer of 1968 brought me to England, Belgium, Germany, Austria, and Switzerland. I was captivated by the majesty of the Alps and the haunting beauty of the English moors. These trips were not long enough, and I returned to Europe after graduating from Indiana University in 1970. By now, landscapes were the dominant theme as I traveled for fourteen months in northern Europe, Bulgaria, Yugoslavia, Turkey, Greece, and Italy. I was always attracted by the beauty of natural landscapes, and so this trip was a fulfillment of a traveler's dream.

Because of pinched financial circumstances, for my third trip to Europe I could take with me one hundred rolls each of black and white and color transparency film. This forced a rigorous conservation of film. Concentrating on composition and exposure, for each landscape I allowed only one frame. Looking back, it was excellent training, for now that I work with 4x5 and 8x10 sheet film the skill of being selective is particularly handy.

The young, innocent eyes that first photographed Europe were looking at landscapes directly, looking at the beauty of the mountains directly, without any philosophical content other than being directly impressed by what I was seeing–the overwhelming beauty of the countryside. Throughout these early travels, I was directed to different aspects of nature. As one gets older he begins to understand both the reality of nature and the nature of reality. One begins to read the book of nature, to learn and understand its symbols, and he begins to understand more of nature's meaning. Also, as one matures, he begins to see the nature of reality–of God and of his own soul.

This understanding provides deeper meanings that can be gleaned from the same photograph. I can look at a photograph that I took twenty-five years ago and still appreciate its freshness and innocence, but now I have a deeper response. When I originally made the photographic image, I was responding directly and intuitively–a very pure response. My response to scenes is still pure and direct, but there is a greater depth now because of an understanding of the metaphysical transparency of phenomena. This opens up new levels of meaning. It is an understanding that the elements of nature participate in and reflect the Divine. Nature, in its very being, is a theophany: a face of God turned toward the world.

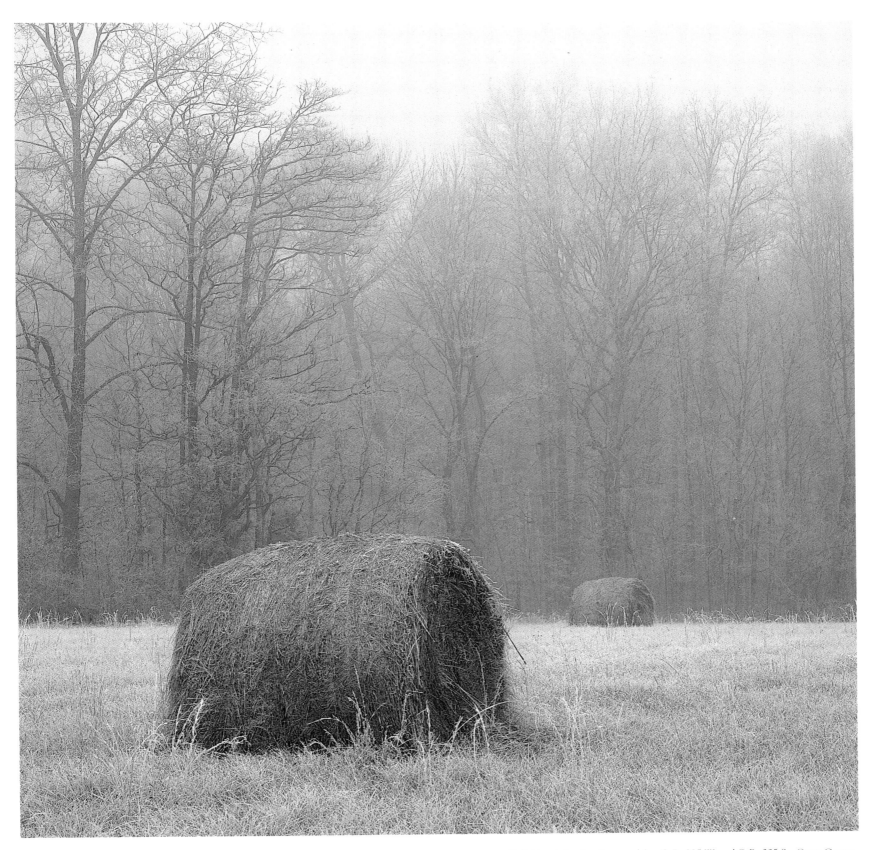

Rolled hay bales, hoarfrost, and fog, C.R. 885 W. and C.R. 225 S., Owen County.

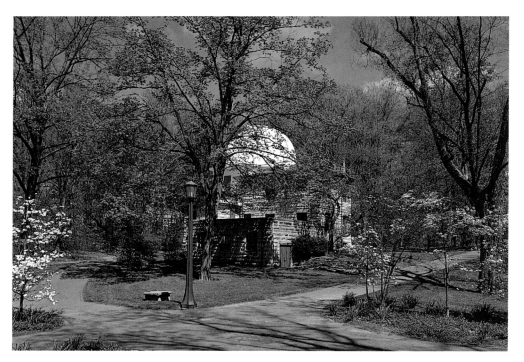

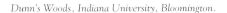
Dunn's Woods, Indiana University, Bloomington.

To further develop this understanding of the meaning of nature, I returned to Indiana University to study comparative religion. This allowed me to concentrate on comparative mystical traditions. Through this study I began to understand the metaphysics of nature and the meaning of symbols. While I did not concentrate on photography, I continued to look with a more intent gaze during my walks through Dunn's Woods on the IU campus. I would simply look and observe, meditating on the symbolism and the meaning of what was before me. Then, one fall afternoon as I walked through the woods on my way home from class, I noticed that the sunlight had a clarity which transformed the trees and leaves. I went home to get my camera and returned to the woods to take photographs until sunset. I went directly to all of the areas that I had studied earlier. I walked from site to site in a concentrated and undistracted manner knowing exactly how I wanted to photograph those trees. This proved to me that my earlier walks through the woods had been with an attentive heart and mind. My photographs became a means of communicating what I saw and learned during those meditations.

One of the many books that had a profound effect upon me was *Sacred Art in East and West* by Titus Burckhardt, especially the chapter "Landscape in Far Eastern Art." For years I had been entranced by Taoist and Buddhist landscape paintings and the respect for and the understanding of the mystery of nature that was conveyed by those paintings. I had felt a kinship with the painters and their perspective. The short chapter explained to me the significance of the metaphysical viewpoint and the contemplative element of

the art. The painters are looking at much more than the external aspects of nature, they are aware of both the manifest and the non-manifest and how in a mysterious manner the non-manifest appears in the manifest, yet never exhausting the non-manifest. In Burckhardt's words:

> A Far Eastern painter is a contemplative, and for him the world is as if it were made of snowflakes, quickly crystallized and soon dissolved. Since he is never unconscious of the non-manifested, the least solidified physical conditions are for him the nearer to the Reality underlying all phenomena; hence the subtle observation of atmosphere that we admire in Chinese paintings in ink and wash.

Later, he says,

> Taoist painting . . . avoids from the start, in its method and in its intellectual orientation, the hold of the mind and feeling, avid as they are of individualistic affirmations; in its eyes the instantaneity of nature, with all its inimitable and almost unseizable qualities, is not in the first place an emotional experience; that is to say the emotion found in nature is not in any way individualistic nor even homocentric; its vibration dissolves in the serene calm of contemplation. The miracle of the instant, immobilized by a sensation of eternity, unveils the primordial harmony of things, a harmony that is ordinarily hidden under the subjective continuity of the mind. When this veil is suddenly torn, hitherto unobserved relationships linking together beings and things, reveal their essential unity.

These last two sentences conveyed to me the essence of why I was interested in photography's ability to reveal the "instant." Film allows light to record a passing moment of time, and that moment opens up to eternity beyond time. If the viewer were in harmony with the moment, then he might transcend the "subjective continuity of the mind," recognizing the "primordial harmony of things." These were the key words: instant, eternity, harmony, unity.

Therefore I now have to say that my photographs are representations of contemplative studies on the metaphysics of nature as theophany. By "representation" I mean the visual result of an inner study. I cannot explain what I am experiencing directly, as much of this contemplation is an interior experience, but at least I can show in as direct a manner as possible what it is that I am seeing with my two eyes.

When I am making a photograph of a landscape, I am not trying to add to the scene anything of myself. As a photographer, I am there as an observer. Yet, to the extent that the observer is present in a contemplative state, the photograph is taken, in Dante's words, "where every where and when are focused." This is to say that my objective is to photograph while "being present" with an attentive mind and heart.

Essentially, I am not trying to impose upon the landscape a preconceived idea of what I want to photograph. I am allowing a direct, intuitive response to the scene to come

forth from within as a recognition of harmony. Harmony is the reflection of unity on the plane of multiplicity. This is what I hope to convey to the viewer. That is why I am choosing one vantage point over another, moving left or right, raising or lowering the camera on the tripod, all as intuitive responses to the perceived harmony of the landscape before me.

Harmony is difficult to achieve in a calculating, manipulating way. Too many photographers approach a scene with a hurried and tense frame of mind, trying to "capture" an image, all the while thinking of this or that and worried that they are going to miss something. They no longer are looking at what is in front of them, but project their own busyness of mind onto the landscape. They come away with photographs containing too much of themselves but missing the Spirit of the Place.

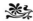

In 1975 my wife Nancy and I moved to Indianapolis. Our son Aaron was born in 1976, and our daughter Hannah was born in 1978. While in Indianapolis we liked to walk on the Marian College grounds, to the pond or through the woods and clearings. We would also drive to Eagle Creek Park and take walks or swim in the reservoir. We took numerous day-long trips to Indiana's state parks, from the Dunes near Chicago to Clifty Falls by the Ohio River. We had to go out of our way to view and participate in nature, but we always knew how important it was to maintain this relationship.

When we moved from the city to the country, we could view woods and open fields from our house and swim in or skate on our pond. Less then a hundred yards away are two small ravines with large moss-covered boulders and creekbeds that fill with streams on rainy days. We can watch (and sometimes hear) the ice forming on pools during the winter and observe the variations in the thickness of the ice throughout a several day period. We can stand at the pond's edge and listen to the frogs as the setting sun or the full moon reflects on the surface of the water. These were always important, but now they can be experienced on a daily basis and be photographed whenever the weather conditions are right.

While I have traveled through most of the contiguous forty-eight states and through many countries in Europe, most of my travels in the last twenty years have been in Indiana. My earlier journeys were important to me, but the desire to learn from external travel has been replaced by a desire to learn from the journey within.

Looking and meditating on what is close at hand creates an intimate bond with one's immediate surroundings. Observing a waterfall of one foot or a hundred feet, the difference is largely a matter of scale, for the essential principle of water falling upon rock can

be understood through either. The senses can be overwhelmed by the breadth of Niagara Falls or impressed by the height of Yosemite's Bridal Veil Falls, but one may miss the contemplative value of observing a one-foot falls, as if the small scale had nothing to offer. The principles are the same and can be discerned spiritually by the contemplative mind; there is an adequation of what is within to that which is without on a principial ontological basis.

Native Hoosiers frequently feel embarrassed by the lack of a large-scale grandeur in our state. They too often overlook the beauty that is around them. The beauty of Indiana is often found in its subtlety, which forces the viewer to be more responsive to what is before him.

My interests have been in the principles by which nature has come into existence, and in how nature manifests those principles in theophany. Therefore, the scale of nature is inconsequential, because one can observe the principles in what is small, close and intimate, if one is meditating on nature as theophany—the formless appearing in form. William Blake has written in "Auguries of Innocence":

> To see a World in a Grain of Sand
>
> And a Heaven in a Wild Flower
>
> Hold Infinity in the palm of your hand
>
> And Eternity in an hour.

Huang Po expresses this as well:

> Hold fast to one principle and all the others are identical. On seeing one thing, you see All. On perceiving any individual's mind, you are perceiving All Mind. Obtain a glimpse of one way and All ways are embraced in your vision, for there is nowhere at all which is devoid of the Way. When your glance falls upon a grain of dust, what you see is identical with all the vast world-systems with their great rivers and mighty hills. To gaze upon a drop of water is to behold the nature of all the waters of the universe. Moreover, in thus contemplating the totality of phenomena, you are contemplating the totality of Mind.

I was born and grew up in northern Indiana, where the land was flat and the horizon wide. Then I lived for sixteen years in the central part of the state, before moving to the southern uplands. Therefore, I can call all of Indiana my home, although my roots are now sunk into the soil of Owen County. Indiana is a beautiful state, and it has taught me much about becoming aware of beauty in its subtlest forms.

Through photographs I have attempted to present this unseen beauty and harmony.

By limiting my photographs to Indiana, and in this book to the southern uplands, I am concentrating on what is physically closest to me and perceiving its beauty. To look at nature you need to start wherever you are; if you are in a city or town, you look at the trees along the streets or in parks; you look at the sky and observe its hourly changes. Don't wish you were somewhere else. Look at what is around you. If, however, you can drive on country back roads or take hikes in state parks or nature preserves, you will be able to surround yourself with natural beauty. It is my wish that these photographs can awaken in others their appreciation for and contemplation of the beauty relating to the natural landscape—to see nature as theophany.

The present photographs were taken with four different cameras, each with a different format. The panoramic images were produced with a 1928 Deardorf 4x5 Special, which is a wooden tripod-mounted camera. On the back of the camera I have added a 1950 Burke and James 6x17 centimeter film back; this allows a 120 size roll film to be used and gives four images to the roll, each image being 2 1/4 x 7 inches (6x17 cm) in length. This old film back was adapted to the Deardorf by Benjamin Queary, producing a panoramic view camera with all of the movements of the lens and film plane that are expected of a field view camera. The image ratio is approximately 3:1.

The second camera used a 4x5 inch format; this camera is a 1945 Deardorf lightweight field camera. This can be carried easily in a backpack with six lenses and twenty-five 4x5 film holders.

The third format is square, the film size being 2 1/4 x 2 1/4 inches on 120 film. I used a 1963 Hasselblad with three lenses: 50mm, 80mm, and 150mm.

The last format is again rectangular, but the film size is 35mm. The camera is a Nikon F-3 with a motor drive. I like to work with the 35mm PC (perspective control) lens, because this lens can be shifted to give undistorted images, keeping trees parallel.

The different formats give the photographer the opportunity to choose the camera which most approximates his immediate vision of the landscape. Each scene can be photographed in a different way corresponding to that vision. All of these cameras are used for the qualities inherent in their respective formats.

DARRYL JONES
Owen County, Indiana
March 1995

Author's Preface

This was not meant to be a personal book in any autobiographical sense. I knew that the photographer, my friend Darryl Jones, had done many years of work photographing a region in the hills of south central Indiana and I understood that these beautiful pictures were his tribute to God's handiwork here, here in his home country which is also my home country. I was pleased that some of his pictures were going to be published in a book about my favorite place, and honored that he wanted me to write some words of commentary to go along with the pictures.

Keeping in mind that one picture is estimated to be worth ten thousand words, I really didn't expect my prose to add much. In fact I felt that it would probably be superfluous. But I wanted to try to add a little to the tribute if I could, because my roots are here too. I have been intimate with this countryside all my life except some years when I was away doing city work, and even then I knew that I belonged here and was always trying to come back.

And so when I began looking at Darryl's pictures and figuring out what to say, I quickly realized that I had so much to say about this place, and about living here, that I could fill the whole book up with words and there wouldn't be any room for the pictures. Well, that wouldn't do.

So I took my flood of feelings about this place and started distilling out anecdotes about people, myself included, who are the way they are because this is where they live.

I do believe people are the way they are because of where they live, even if they aren't aware of that.

While I can't explain why that's true, I hope by these words and anecdotes I can make it quite evident that it is true. If I know anything I know that that's true in my case, and that's why this got to be a personal book.

JAMES ALEXANDER THOM
Owen County, Indiana
January 1995

THE SPIRIT OF THE PLACE

You have roots in a place, or you don't; you can't force them.

It helps to be born there, though that's not your choice to make.

But there are things you do that feed and strengthen those roots.

The four best root fertilizers you can give in your lifetime are sweat and blood and tears and ashes.

You can give both the sweat and the blood by stringing barbed-wire fences, by clearing briars and thorny locusts out of the fencerows, by picking raspberries and blackberries, or by hurting yourself with the tools or implements you use on behalf of your place.

Or by giving birth there.

You can give sweat and tears and ashes by burying a beloved animal or spreading a parent's ashes over the ground.

You can give all of them, sweat, blood, tears, and ashes, by fighting in a war for your country. If you're lucky you won't have to do that right there on the place of your own roots, but even then they all go to fertilize it.

And then you can die in that place, and if that is the place where you *want* to die, then that's really where your roots are.

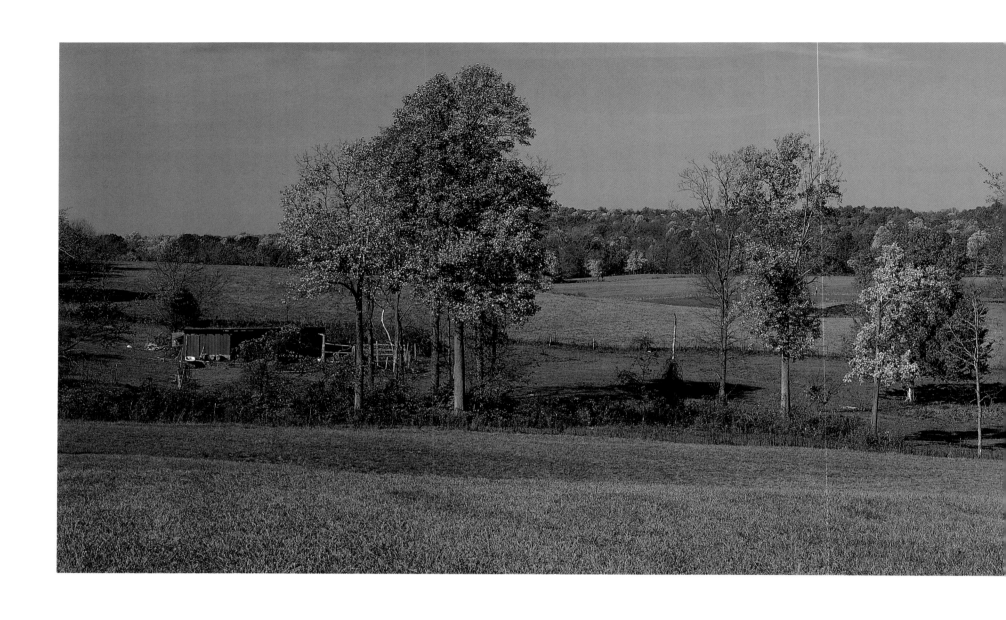

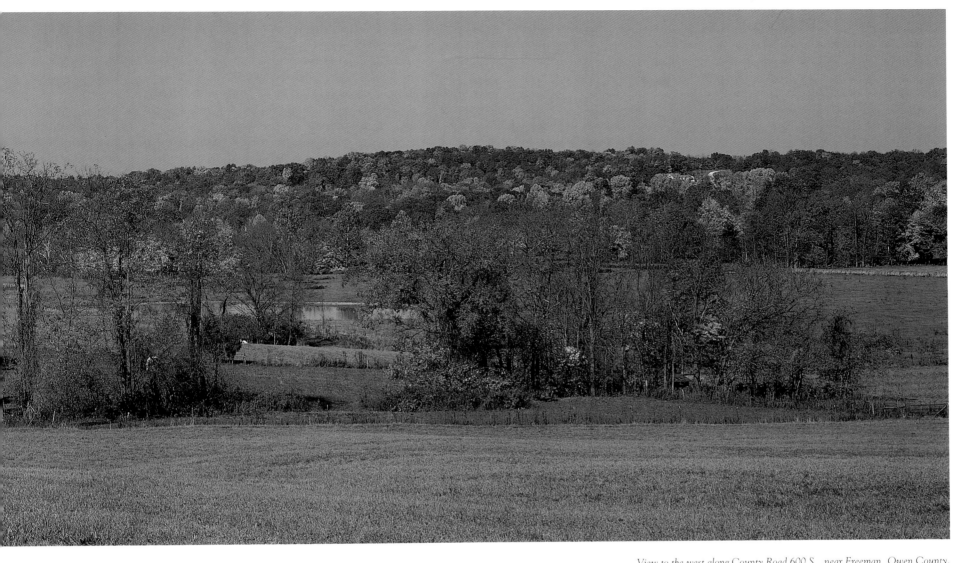

View to the west along County Road 600 S., near Freeman, Owen County.

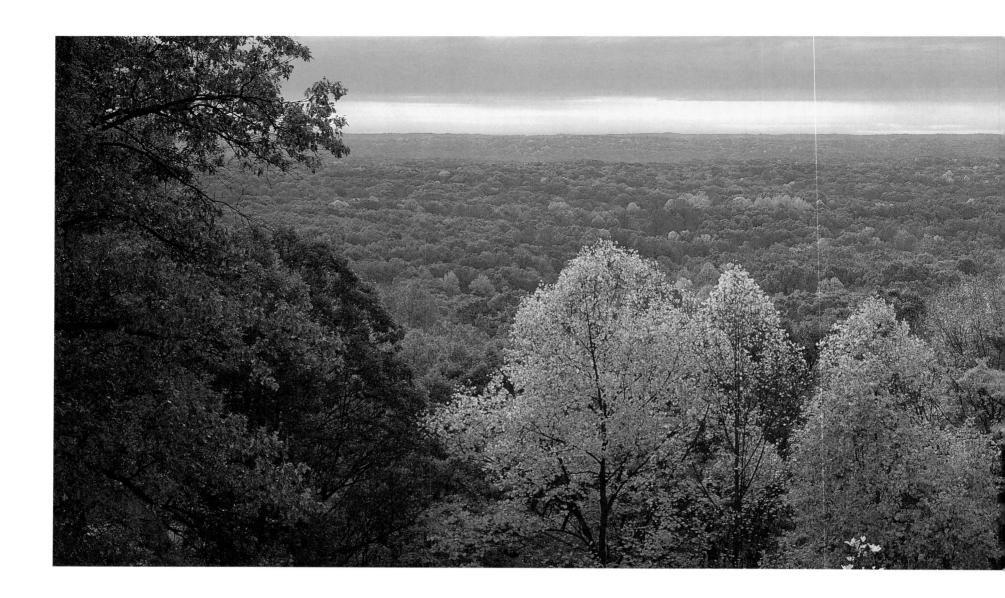

This Upland part of Indiana is steep, with V-shaped gullies and narrow ridges and some substantial hills, and is therefore considered different from most of Indiana, the flatlands.

But if you stand on a ridge and look out across the valleys at the other ridges, you see that those ridges are level, and the horizon is likely to be as level as the horizons are in the flat country. Maybe you've noticed that.

The reason is that a long time ago this was flat, too. It was an ancient peneplain, originally dried-up sea-bottoms, as the geologists explain it. Since long before the glaciers came down, erosion has been washing out the softer parts faster than it could wear down the harder parts, which are now these ridges we stand on to look over the valleys.

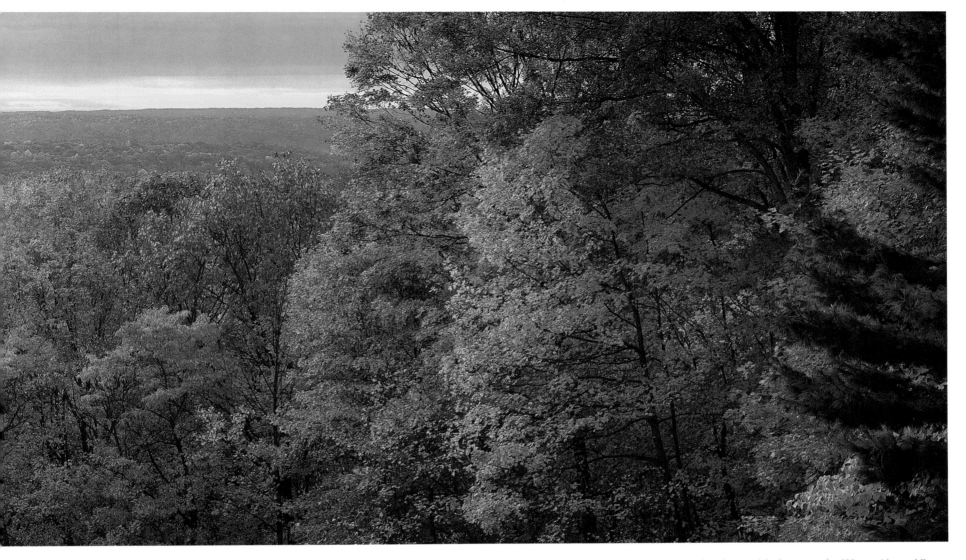

Scenic overlook in Brown County State Park with view of the distant woods of Hoosier National Forest.

What's different about this part of the state is that when the glaciers came down during the various stages of the Ice Age, they all stopped about where Martinsville is. Sometimes they went on down both west and east of this region, but they never glaciated the area of Bloomington and southward from there.

The result of all that is that this part of south central Indiana was unglaciated, and therefore was not ground down, squashed, and filled in the way the rest of the state was. This is ancient land and has been just naturally eroding for a long time, which makes it steep and deep and interesting and a joy to look at.

You can study what ice has done on a large scale by going north to the parts of the state that were glaciated. But ice is powerfully at work on a microscopic scale even now.

Moisture gets into earth and rock, and on a cold winter day it crystallizes by freezing, exerting as much pressure as 20,000 to 30,000 pounds per square inch. Solid rock fractures; soil expands and shifts. Stones and fenceposts move upward during frosts. Freezing and thawing alternate many times every winter in our climate, so these invisible forces are busy wearing down the surface of our landscapes.

And then there is constant chemical weathering. Limestone in particular is always being worn down by carbon dioxide and water, as our caves and sinkholes in the Hoosier hills make dramatically clear.

Even plants and animals work to wear down the earth's surface. Underfoot at all times, roots and lichens and moss and bacteria are breaking down rock, while earthworms, termites, ants, and moles stir and reshape the soil.

I wouldn't presume to give readers a geology lesson. This is only a reminder that if you get down close to the ground where you live, you can not only see little beauties, but understand their big effects.

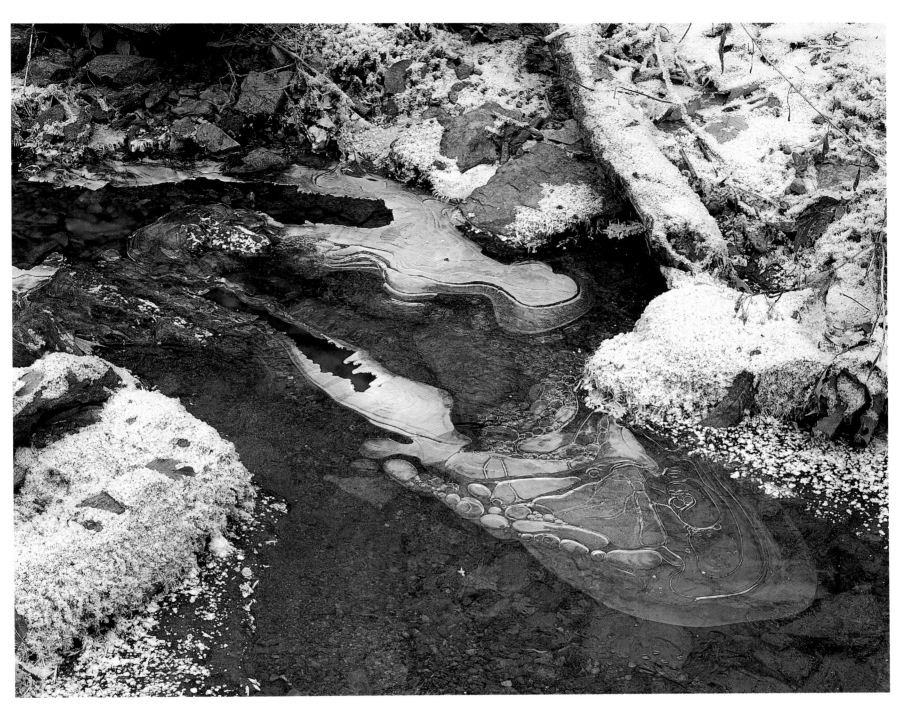

Ice forming on creekbed, Owen County.

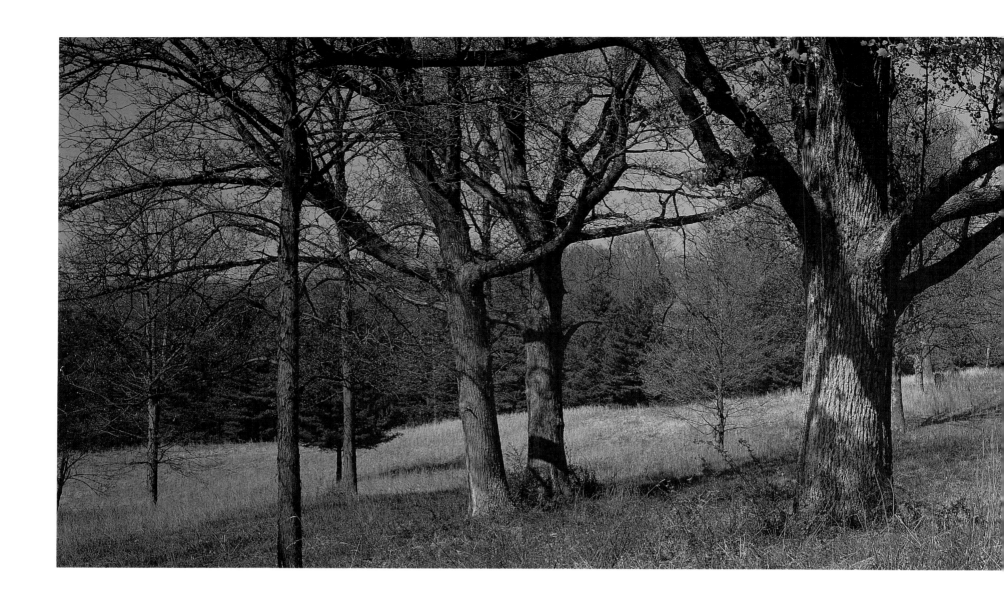

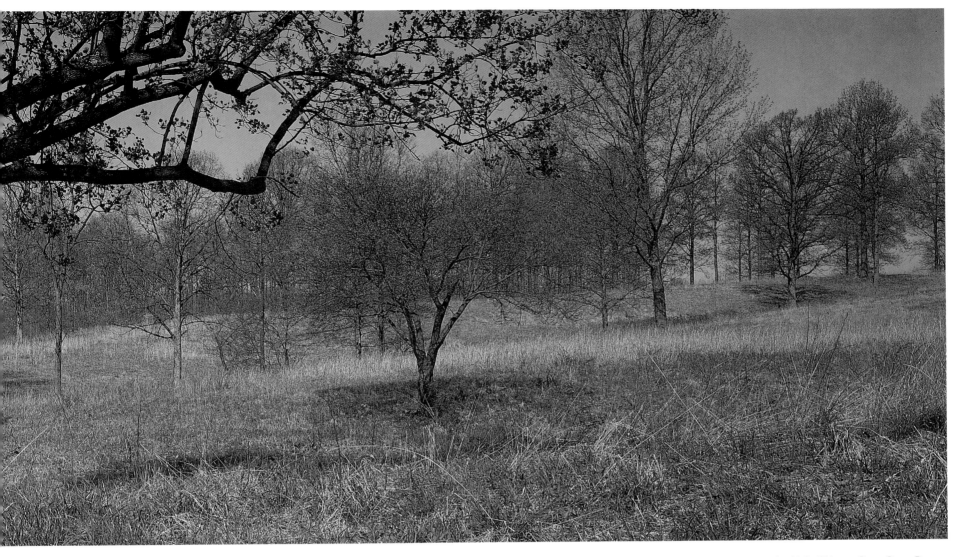

Redbud tree on west side of S.R. 231 near Carp, Owen County.

"Indiana" means "Land of the Indians," which is what the United States government named this territory even while it was scheming to take it away from them.

The Indians believed that all land belonged to God, and the notion that it could be parceled out and sold by man was incomprehensible. In a historic face-to-face meeting at Vincennes, the Shawnee leader Tecumseh exclaimed to William Henry Harrison, governor of the Indiana Territory: "Sell a country? Why not sell the air, the clouds and the great sea, as well as the earth? Did not the Great Spirit make them all for the use of his children?"

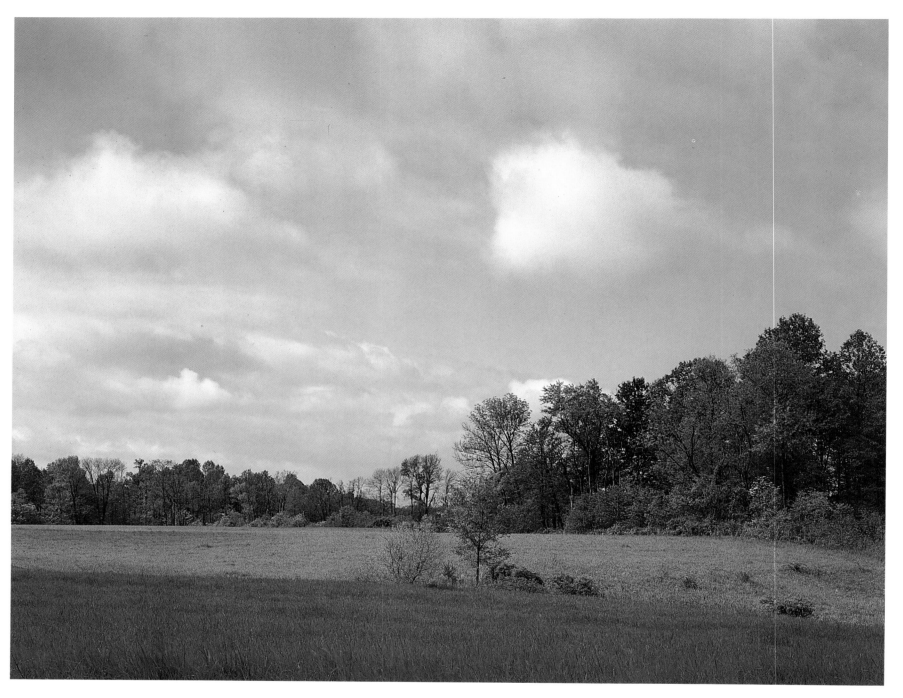

Field of grass near C.R. 200 S. near Patricksburg, Owen County.

Birdhouse, flag, and white picket fence, Gosport, Owen County.

Tecumseh might as well have been talking to a wall, because Harrison was the most efficient executor of the plan of the Northwest Ordinance of 1787, which was to "extinguish Indian title" to the lands and turn them into states, all divided up into counties and townships and sections and plats—a gridwork of imaginary lines on the earth by which a mortal could buy a piece and make everybody else stay off.

It was essentially those irreconcilable concepts of domain that foredoomed any coexistence of the red and white cultures on this continent.

Although I "own" more than a hundred acres of Owen County according to the present law of the land, I no more believe I really own it than that I could own that cloud passing over my house or the sunset outside my west window. Nor do I believe that my neighbors to the north, east, south, and west own what they call theirs. Like the Indian, I know it belongs to God.

It is easy for me, when looking over a landscape, to imagine how it would look if all the paper pertaining to it—treaties, deeds, titles, mortgages, statute books, real estate ads, abstracts, surveys, writs, lawsuits, bills, wills, plat books, and tax receipts—were to escape from the courthouse and flutter down like snowflakes to cover the countryside. It would surely blanket every square inch like a snowfall.

Of course it would not be really white like a snowfall; if that paper blizzard included all the paper money involved, there'd be a green tinge. In our society, land belongs to the Money God.

Each piece of paper seems critically important at the time, to the landowners and realtors and lawyers and bankers involved. But in the long run, they will all be dead, the land will still be here, and all their paper will have proved to be just so much expensive mulch.

Maybe Tecumseh could take some comfort in that thought.

When I think the word "landscape," I remember something my grandfather used to say to amuse us. He was a big, stout New York Central engineer who showed gold when he smiled. He lived in Elkhart and ran steam locomotives, which of course produced overweening pride in us grandchildren, especially when Grandma with her rail pass would take us riding on Grandpa's very own train. He also built with his own hands a big log house, which was another source of awe and pride for me and had a big effect on me half a century later—but that's getting ahead of the story.

Heaven knows how many thousands of landscapes he saw slip by in his career on the Big Four routes and when he and Grandma went on cross-country vacations in his long, black, shiny 1936 Olds sedan with its white sidewall tires. Maybe it was that eternal backward gliding of the views that caused him to pun: "Let's drive out and watch the land escape."

That was funny to me then, but now I think of it with a bittersweetness—because if there's one thing modern Americans do it is watch the land escape.

I mean that in two ways:

Most of us who flatter ourselves that we've seen our country have actually just seen it slip away beyond our car windows. We might as well have just watched a travelogue on the TV screen. My grandfather had seen plenty of the country pass by beyond windows, but he had also been intimate with the land in those ways you have to if you're going to know it. He had been a hunter and a bass and muskie fisherman and a backwoods guide and a gardener and farm worker and builder and stonemason. I remember once when he asked me if I wanted to see a photo of the cabin he'd lived in while guiding in Upper Michigan. All you could see was a pine woods full of snow so deep that only a chimney and a pair of snowshoes were visible. That was a man who knew the places he'd been in. Those who see the country from a car are just watching the land escape.

The other way we watch the land escape is by seeing it go down under bulldozers and development and pavement and clearcutting and junk. In the six decades of my life I've seen almost every one of my favorite places disappear one by one. When I can, I put up a fight, but mostly I have to stand by helpless and frustrated and "watch the land escape."

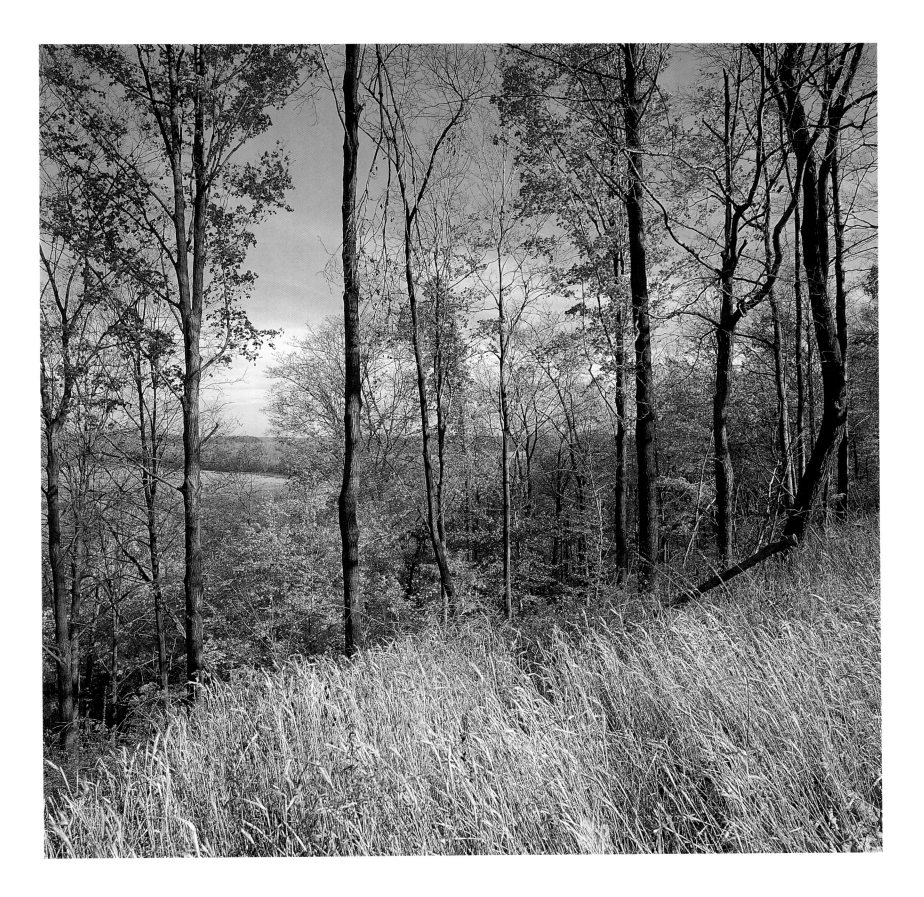

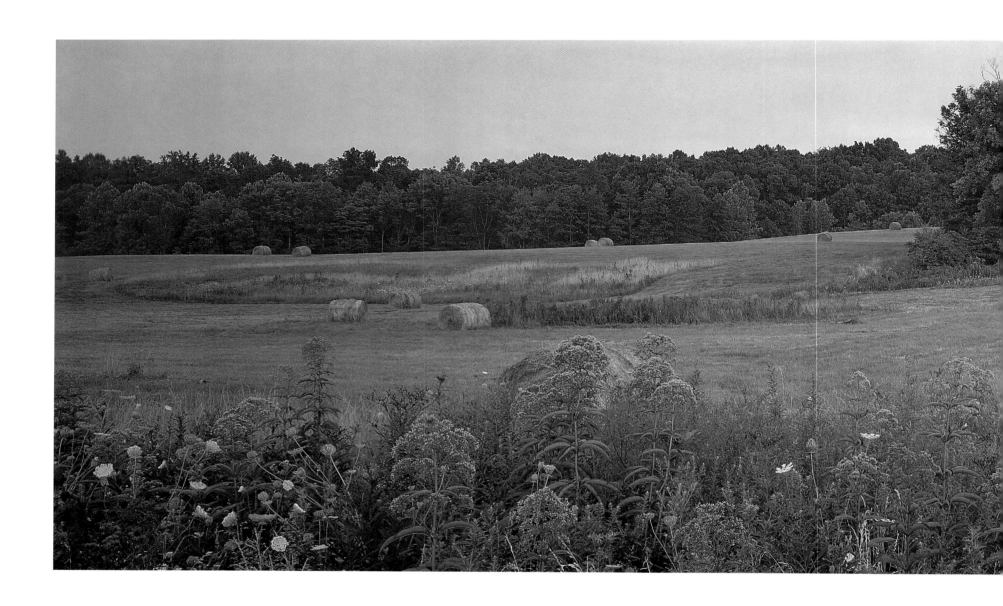

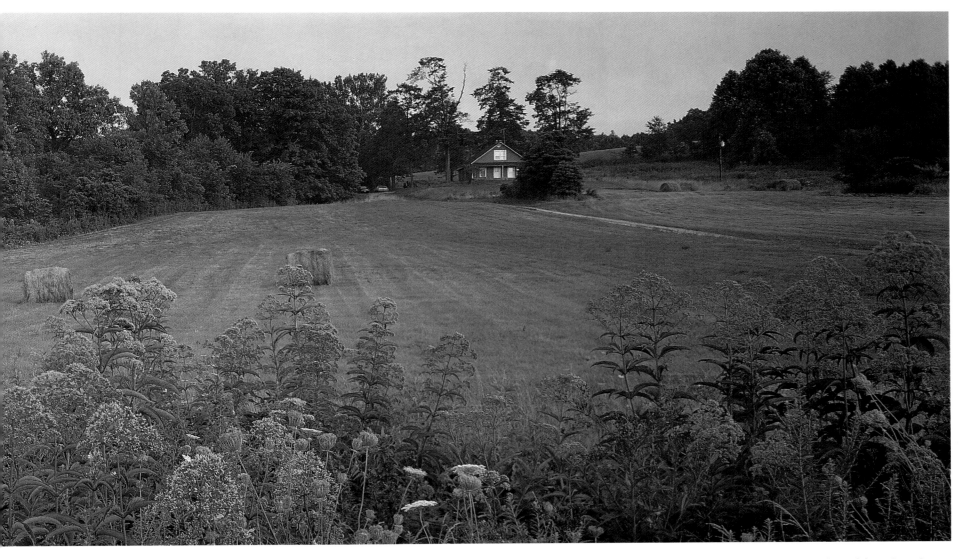

Late summer colors, S.R. 246 east of Patricksburg, Owen County.

If a landscape can shape the course of a human life, here is a photograph of the landscape that shaped mine. This is the view from my house as I look westward over Owen County, and here (in much less than ten thousand words) is how this landscape shaped my life:

When my mother was a country doctor in the 1940s and my father was an Army doctor serving in the Pacific, Mother used to make house calls to a family of elderly Quakers who lived in a sagging old pioneer house on this ridge. If guests were here late in the afternoon, the old folks would lead them a hundred yards down the road to this exact spot to watch the sun set down the valley below.

I was about ten years old and I loved those old people of the Macy family and the way they lived, and the notion got planted in my mind like a seed that I would like to be able to watch sunsets from this very place from then on. I thought that this should be the place where I would live. The house I loved most at that age was the log house my grandfather had built, and so the house I envisioned was a log house, which I would want to build myself, as my grandfather had done. Those weren't terribly tall dreams for a ten-year-old, but of course not many ten-year-olds' dreams actually come true.

Mine did, some forty years later.

I had worked as a journalist in big cities for a long time, and at about age 50 I had a chance to go to work for one of the world's most prestigious magazines. In many ways I

wanted to do that, but I knew that living in the Washington, D.C., area would be a great detour from my childhood dream—such a great detour that I might never get back here. So I asked for more than the magazine would pay me and they didn't hire me. I sort of knew what I was doing and why, but some of my decisions were barely explainable, and probably were being made not consciously or rationally, but by the pull of my roots.

At that time I was living in a Chicago suburb, in a condominium complex. To go downstairs and outside I had to unlock three doors, two of them with a programmed electronic key, and when I got out, all the outdoors was paved. The few neighbors I ever met there had just one topic of conversation, which in one way or another was the price of things.

The place was killing my soul. I started making as many trips down to Owen County as I could. I would visit at my mother's house, which was right where the old Macy house had been long ago, and I would walk this ridge road, and stop and talk with neighbors about the land and the tools they used and the work they did, and about the generations of their families that had lived here. Whenever I could, I sat out here on a rock or a stump and watched the sun go down. At length I got the idea of writing a story on the Indiana hills for the *National Geographic*. They bought it, and the story was my tribute to this region and the people whose roots are here, and the values they had, and the connection between the way they were and the place where they lived. During the months I worked on that story I was so comfortably at home that I knew I couldn't stand to live any longer in Chicago. So I made plans to move from a county that had five million people to a county that had 17,000 people. To me that was a step up toward a better life.

I found an old house for sale about a half mile from this sunset overlook, a place where I could live until I might be able to build the log house I had dreamed of so long before. For a few years I taught journalism at Indiana University and wrote books at night and tried to save money for a piece of land overlooking the valley.

By then my mother, who had retired from medicine and had succeeded the late Mrs. Macy as the resident sunset-watcher on this ridge, decided to divide her acreage among her four children.

The piece I chose overlooked the valley to the west and fronted on Stogsdill Road right along the ridge, including the very spot where we used to come with the Macy family to watch the sunsets.

In 1981 my sister located for me a vacant log house in another part of the county. It had been the home of other Owen Countians for many generations. In about 150 years it had become drafty and out of plumb, and the elderly widow who had moved out of it

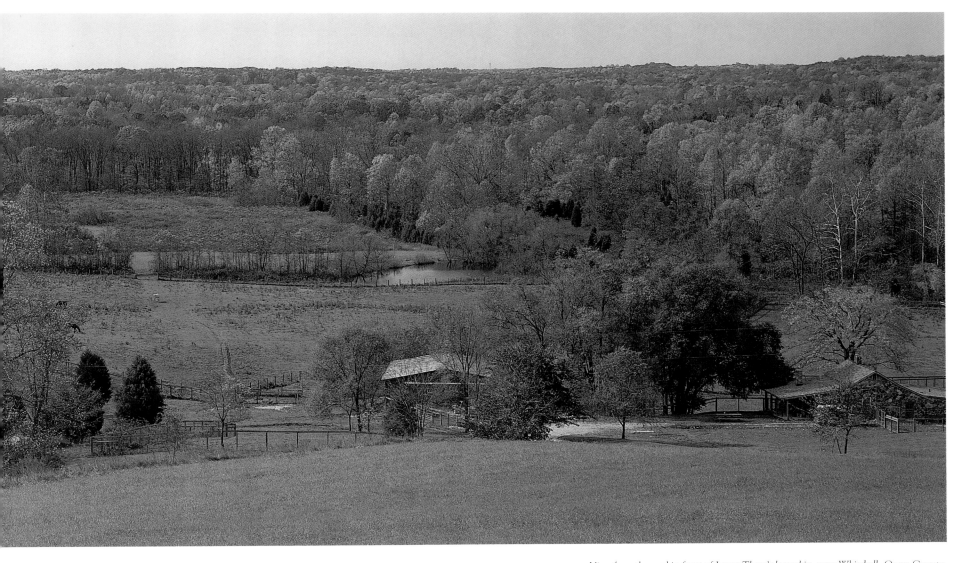

View from the road in front of James Thom's log cabin, near Whitehall, Owen County.

into a trailer wanted it removed so she wouldn't have to pay taxes on the structure. I undertook the task of taking it down and moving it to my land on the ridge and putting it back up, which turned out to be the hardest job I had ever done. Being a historical writer, I decided to do most of it with the same old tools and block-and-tackle that the first settlers would have used—research, I called it. In a year I had the great logs re-erected over a full basement, having camped much of two winters and a summer on the construction site. With the little money I had coming in, I hired a resourceful Owen County carpenter, Deryl Dale, to help finish the house while I divided my time between

the housebuilding and a huge novel I was writing. By the time the house was finished in 1986 it was paid for, and so I think I can say that this is a house that was built twice without having a mortgage on it, and that is one of the best things about it.

The house is made of hand-hewn poplar logs as much as two feet across, and these logs were once trees in Owen County, back in another century, so the roots of my house are here too. The sandstone foundation blocks came from the old homesite and so I know they are Owen County natives too. The sill log and girders I cut and hewed here on my own land. I know the oak floorboards are from this county, and the elm-block parquet segments of the kitchen floor I cut myself from an old dead tree thirty feet from the house. So this house is very local, and since I have lifted and manhandled about every bit of it, it has a great deal of me in it, and that attaches me even closer to this ridge where my house stands.

And then the house is here where it is because of that long dream I had as a boy. Having that much of myself in this piece of land and in this house, I don't intend to move anywhere else.

So I am here because of this view, and my house and I are very local and very integrated with each other, and when I die I expect it will be here, and as I've said, if you want to die in a place, that's the place where your roots really are.

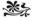

Here is a true story about the piece of land where my house stands.

Back in 1983 I was engaged in two of the biggest tasks I had ever undertaken: putting up a log house and writing a huge book about the famous Clark family of Virginia. Johnny, one of the Clark youths, was a prisoner of war on a British prison ship. One of his fellow prisoners was a real Virginia neighbor named Micajah Freeman. Johnny Clark died soon after his release from the prison ship. His family soon moved to Kentucky.

Years after I finished that book, I was leafing through the title abstract on this piece of my land. There was a land sale document signed by President Monroe.

And the name of the first white man to own this piece of land was Micajah Freeman, that Revolutionary War veteran. I hadn't followed through on researching his life after the prison ship, but apparently he ended up right here on this same Indiana ridge where I did.

Need I say that the hair on the back of my neck prickled when I discovered that coincidence?

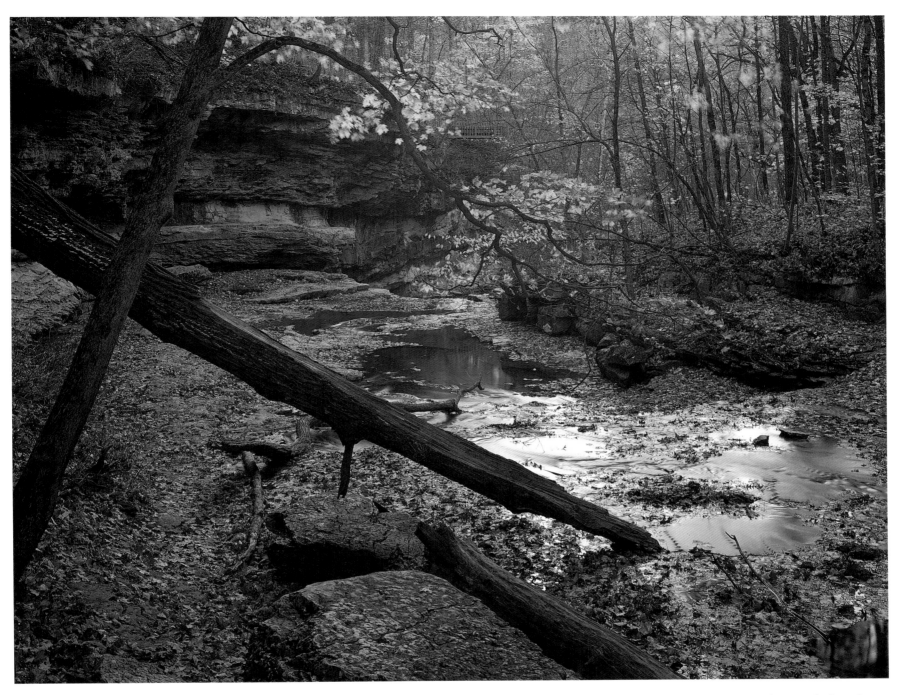

Creek just before the falls at McCormick's Creek State Park, Owen County.

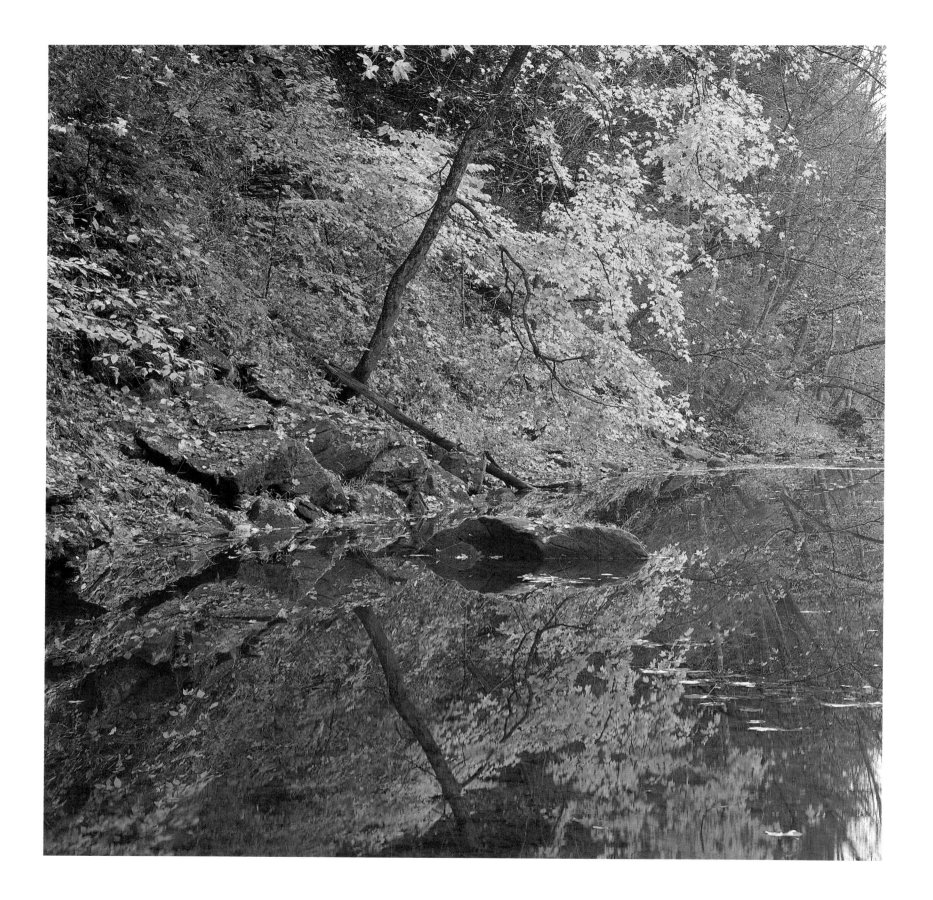

This ridge is like a limestone backbone. In some places the stone protrudes right through the thin soil. It is pocked with sinkholes and underneath run miles of caves. Eastward the land slopes steeply through an old woods of oak and beech and hickory, to the bed of Raccoon Creek, which is a dry gully full of wildflowers except right after a heavy rain, when it roars with runoff from the ridge and leaves fossils exposed. Beyond that creekbed is the Monroe County line. At the southeast corner of the tract is a hidden spring, which is an imperceptible trickle but nevertheless marks the beginning of the all-season creek. Within two miles downstream there are three little bridges where Stogsdill Road crosses the creek. Just a few miles west, in the same township, the creek has grown wide and deep enough that one of my best friends can walk down from his log cabin and catch fish for his table.

I like knowing that I can put a canoe in Raccoon Creek and go to New Orleans by way of the White, Wabash, Ohio, and Mississippi rivers, if I get the time and the inclination. Or I could go downstream a way and then back up other streams and visit just about everybody I've ever met between the Rockies and the Alleghenies, from Virginia to Ohio to Minnesota to Montana to Arkansas to Tennessee.

When you know the place where you live, you are aware of where the rainwater drains from and where it drains to and you know that one of the ways we are all connected is by the flow of the water over the land.

And if you think far enough about it you know that a molecule of water that once fell from you in a tear or a drop of sweat or a drop of blood forty years ago might be back in your veins or in your bladder after having gone through the ground and down streams into the sea and around the world as vapor and clouds and back to where you are as rain or snow, and into you via your morning coffee, maybe even having passed through an Eskimo and a fox and an oak tree in the meantime. There is just so much water on Earth and it goes everywhere and has everything to do with the living, wherever their roots may be.

That's because knowing about your place on Earth makes you understand how everyone else has a place on earth. It would be terrible never to know that.

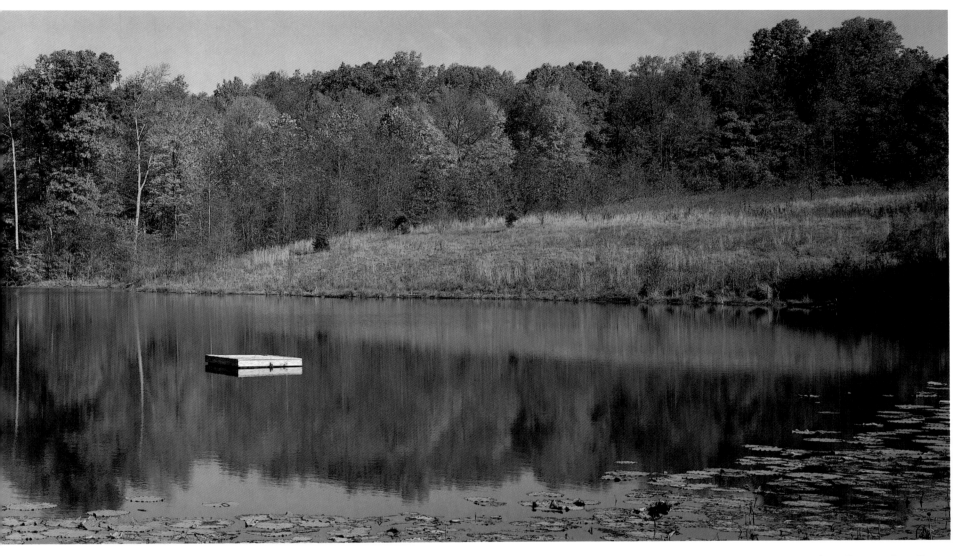

Private pond near Freeman, Owen County.

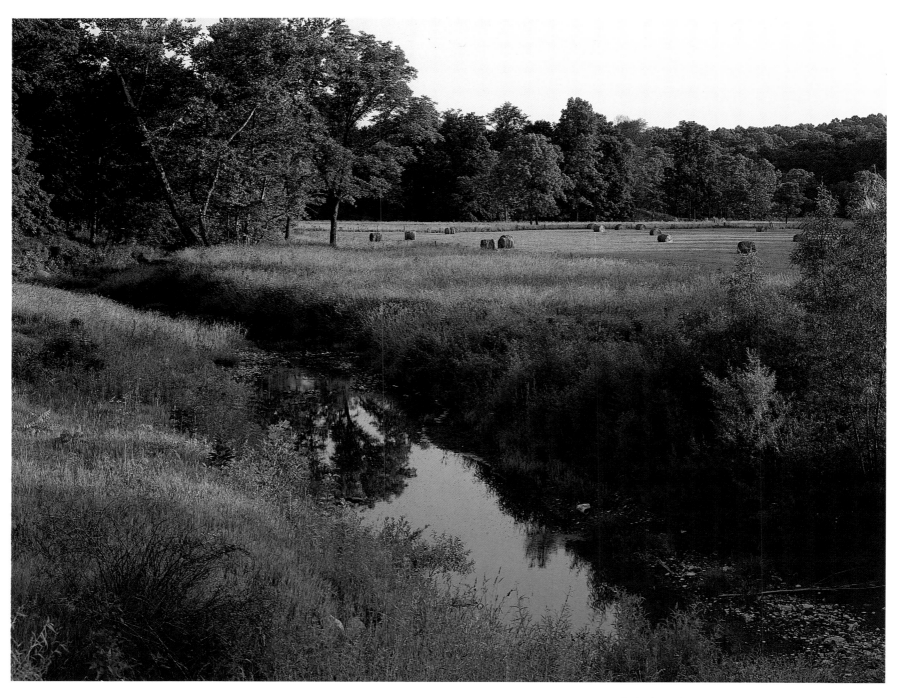

East Fork of Fish Creek crossing S.R. 46 near Vandalia, Owen County.

Part of *being* in a place is getting down into its crannies and staying there long enough to see it in small details. That's as important as glancing over the whole panorama of a landscape, maybe even more important.

Getting down close like that and being still for a long period brings out the antennae of all your senses, so that you don't rely solely on sight.

You begin to hear the music of running or dripping water, the sigh of a breeze, the rustle of leaves and whispering of wind through the grass. After a while, then, you begin to understand how the so-called primitive peoples could believe that spirits were all around them in the natural world.

Under you, you feel stone cushioned by loam and leaves or moss. You feel and smell and even taste the cold dampness of water over limestone and decay of vegetation.

And then when all those five senses are thus tuned in, they awaken that deeper, greater sense: the sense of *being* in the place and a part of the place, enveloped by the place and immersed in the immeasurable time of the place—time manifest in the processes of the earth, the wearing down of rock, the freezing and thawing and flooding, seeding, growth, death and decay, the constant rebirth of plant and animal life. Then you have felt the true spirit of place, knowing that your lifetime in this long cycle is as brief as a spark and is no more significant than the ripples made by a water spider.

The profusion of tiny lives everywhere in nature is astonishing, but that's a wonderment you'll never know unless you get down in some little place and wait and watch.

There are wildflowers you'd scarcely be able to see from a standing position. There are so many kinds of ferns, or mosses, or fungi, that you could make a life's work studying a species. Some people do. And then there are the insects of the ground and the water.

I lie here in a gully and watch the brooklet tumbling over the rocks, and I see an ant at work a few inches away. If I were that ant, the falling water would be on the scale of Niagara Falls. By the vast measurement of the universe, I am not so much bigger than that ant, and am probably not as useful. And by the time that oak tree above me has lived out its years, both the ant and I will have been forgotten.

There's nothing wrong with knowing that. It makes the joy of being here now more intense.

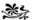

One lesson you learn from living a long time in a place is how to see things changing.

True seeing is not just scanning what's before your eyes at the present moment. True seeing is cumulative. It is adding today's sights onto what you saw yesterday and what you saw in the preceding season, and in this same season a year ago, and the years before, and taking heed of the changes.

It is noticing that there are more squirrels and fewer chipmunks than there used to be, and that the hickory nuts are falling on the roof earlier than they usually do, and that the walnuts are smaller and their hulls are thicker, and that the red cedars are dying for some reason, and that there are more and more houses and trailers in the valley every year, and that the old lady down the hill has become a widow and might need help now and then with heavy things.

It is observing that there are more Budweiser cans and fewer McDonald's hamburger boxes in the trash you have to pick up from along the roadside, and that there are more pickup trucks cruising your remote stretch of road with old refrigerators and used tires their owners want to dump.

It is noticing erosion, or that the dogwood trees have blotchy leaves. Or that the county road crew is getting worse or better about patching potholes in the road now that county commissioners have been elected or reelected.

All those things count, and you can't see them in a drive-by glance.

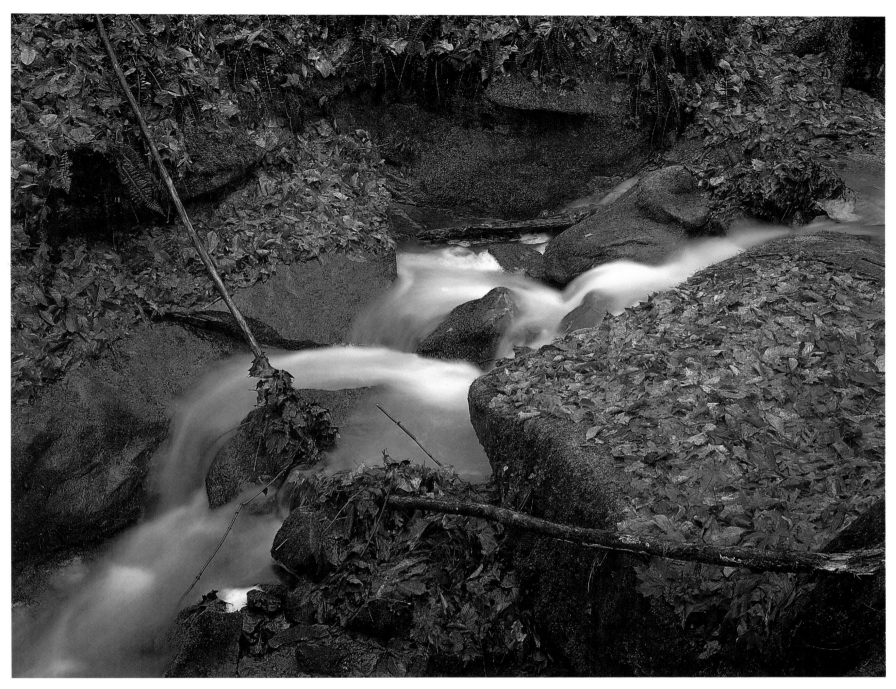

Water, rock and moss, Owen County.

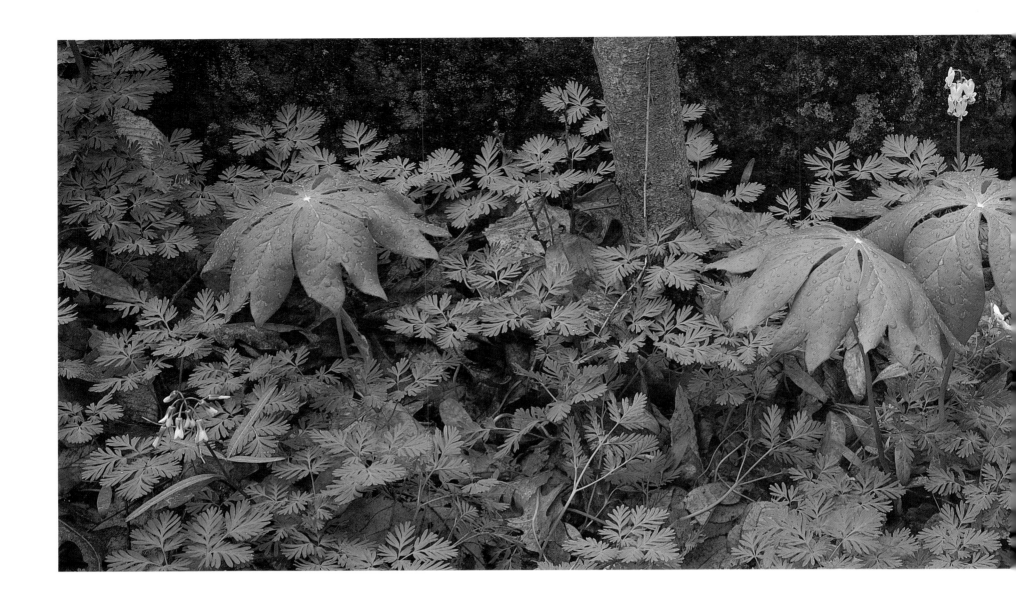

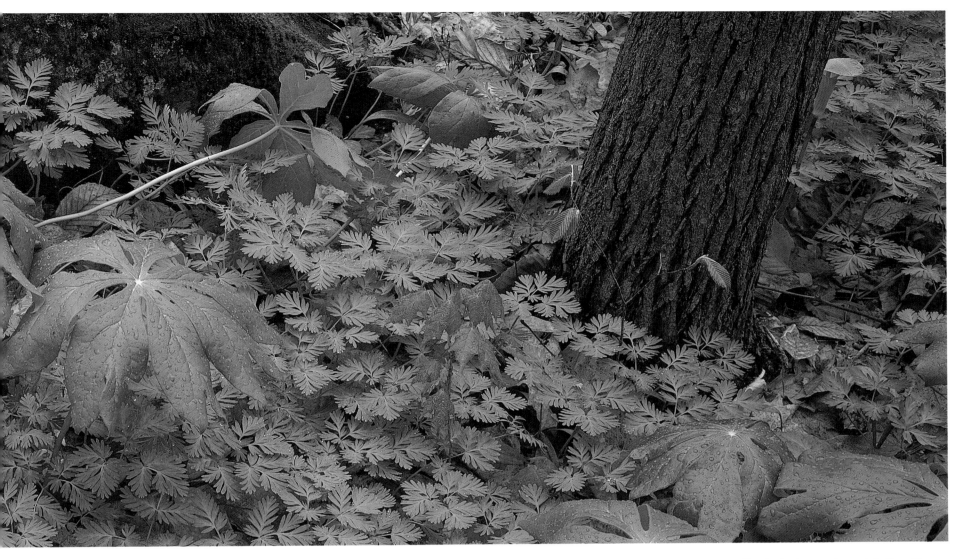

Details of spring growth, woods in Owen County.

This is a picture of a place where I have been watching a quiet, mighty show for half a century. It would tax my powers of language to try to express all it means, so I'll just tell the story of what I've seen.

This limestone boulder is less than two hundred yards from my house. When I was a boy of eight or ten I used to climb on this boulder. At that time I observed with some wonder that a maple seedling had sprouted in a tiny crack on top of the solid boulder.

As I returned over the years I was always surprised to see that the little maple was still alive.

When I came home from Korea I was a little over twenty years old and the maple seedling had become a sapling and it was perhaps half my age then. That was probably when I first really understood that the root of that little maple was actually splitting the limestone as it forced its way downward for nourishment.

I went away and worked in cities for a couple of decades and then when I moved back to Owen County to build my home and stay, the maple was an established tree, several inches in diameter.

In the twenty years since I've been back the maple has increased to this size—it is 14 inches thick now—and that old mossy limestone boulder is still its home and they are inextricably locked together now in a kind of sacred beauty that inspires and comforts me whenever I walk down to see them.

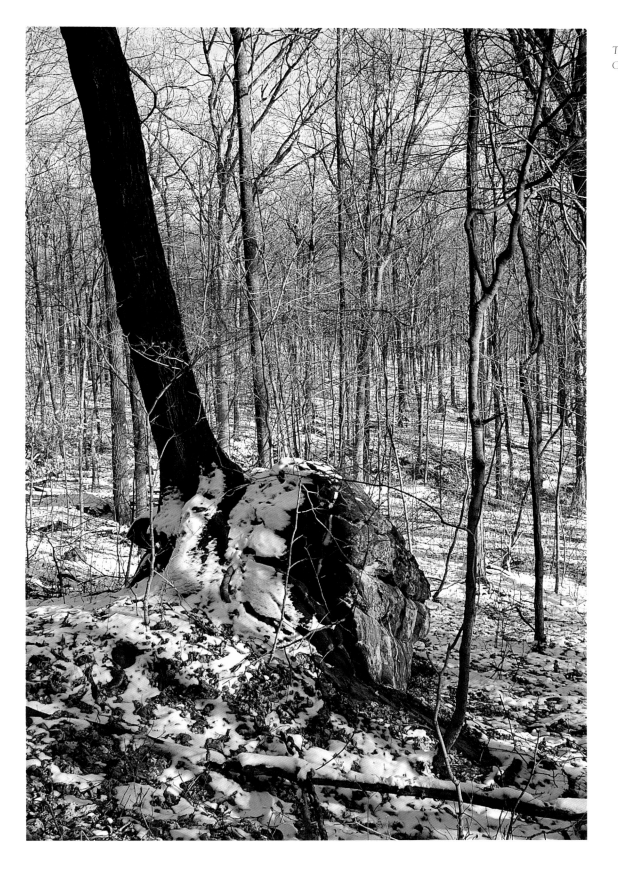

Tree growing out of rock, Thom's woods,
Owen County.

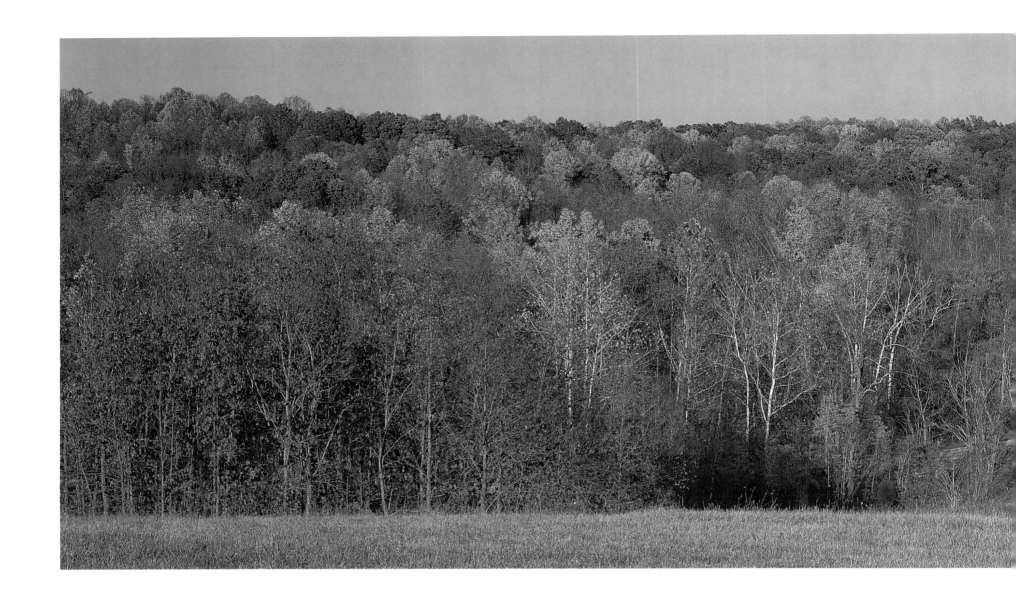

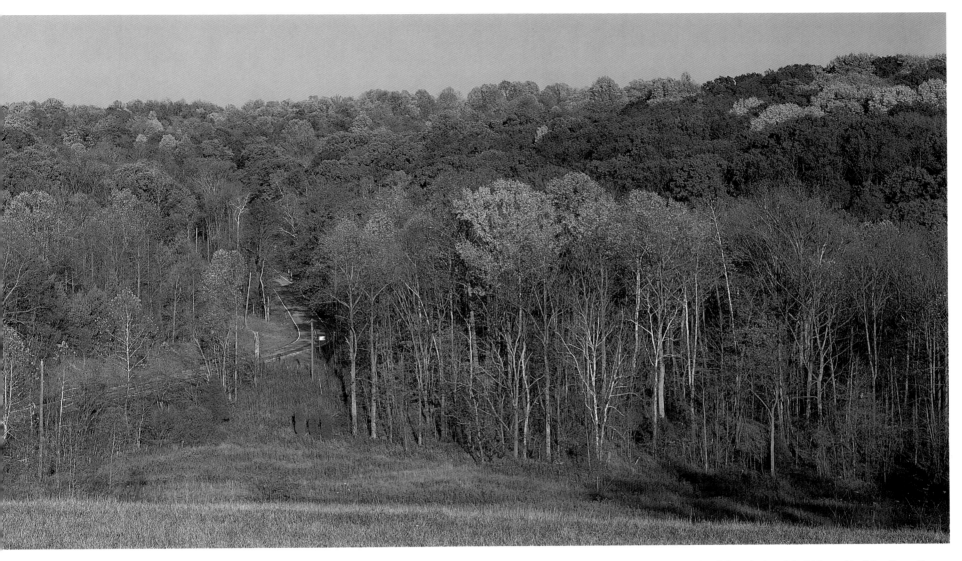

Sycamores amidst a variety of trees, from hill overlooking S.R. 246 near Vandalia, Owen County.

You get to know individually the kinds of woods that cover the hills with their beauty. Not just the ways they look in the different seasons, or the things they provide you, like maple sugar or walnuts and hickory nuts or papaws to eat or sassafras tea to drink, or the medicines they yield, but the properties of the wood itself—for example:

That hickory is the hottest, longest-burning, and best-smelling firewood and is unmatched for making tool handles, while basswood is worthless for those purposes but has an inner bark you can weave fabric from and a soft, smooth wood that's a woodcarver's dream. . . .

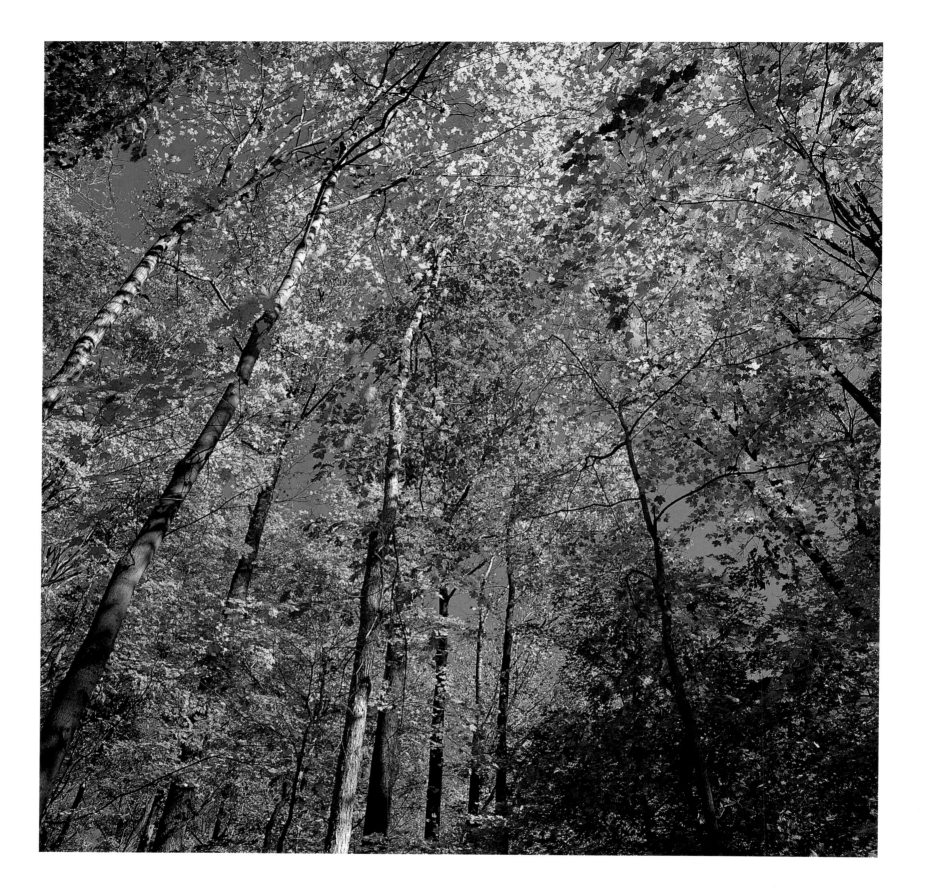

That oak burns slow and hot and is easy to split along the grain but wonderfully strong and rigid for load-bearing timbers in a structure and makes tough flooring with beautiful graining. . . .

That red elm is tough and beautiful and almost rot-proof but so sinewy you can wear yourself out trying to split a little for stovewood. . . .

That beech is good for joists and posts but once it's seasoned you can't get a nail into it without drilling the nailhole first. . . .

That poplar is our eastern version of pine for dimension lumber because it grows so fast and straight, and that it works easily and sometimes has lovely olive or purple colors in the heartwood, and is lightweight, but is weak across the grain, and burns too fast to make a good stove fuel. . . .

That maple is wonderful for smoking meats and is hard to carve but worth the effort because of its pale, translucent finish. . . .

That wild cherry is a great and gorgeous carving wood if you know how to do it without fracturing it along the grain, all statements you can also make about black walnut. . . .

That if you have a grove of locust trees on your land you'll never have to go buy treated fenceposts. . . .

That Eastern red cedar is like locust in this regard, and that the Creator likes its smell so well that its smoke is sacred in ceremonies, like incense in a cathedral. . . .

That sycamores are stately and beautiful and they stabilize creek banks, and that's apparently enough, because their wood itself isn't worth cutting—which is another good reason to let them stand there and be distinctively beautiful.

When you belong to a place you have occasion to use its woods and get to know their traits just as you know the character traits of your neighbors, the ones you can count on and the ones you can't. You have to know how they'll behave under certain circumstances. As one very savvy woodworker near Bloomington stated to me once: "It helps to be as smart as the wood."

Looking up at tree canopy near Coal City, Owen County.

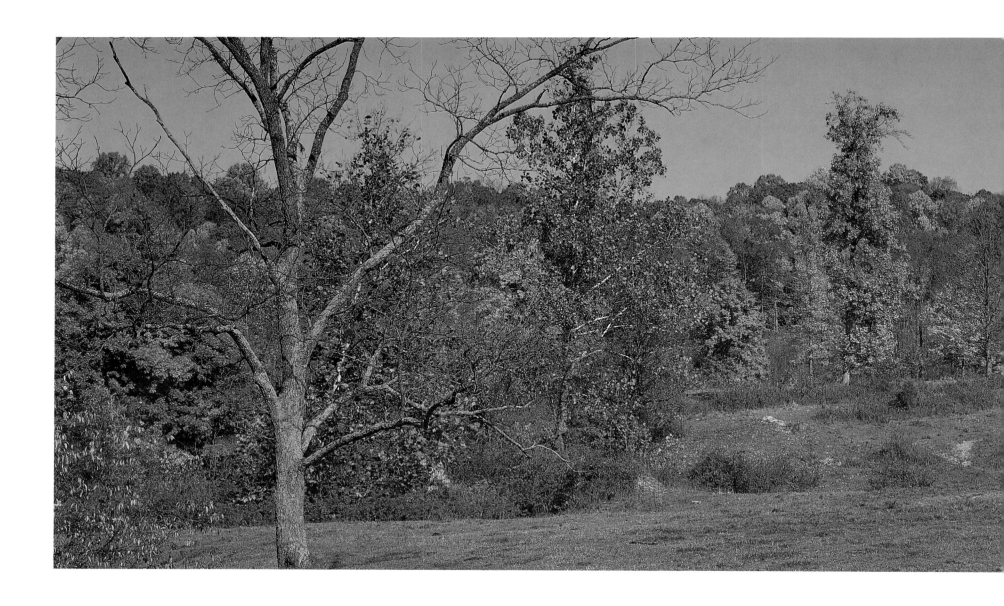

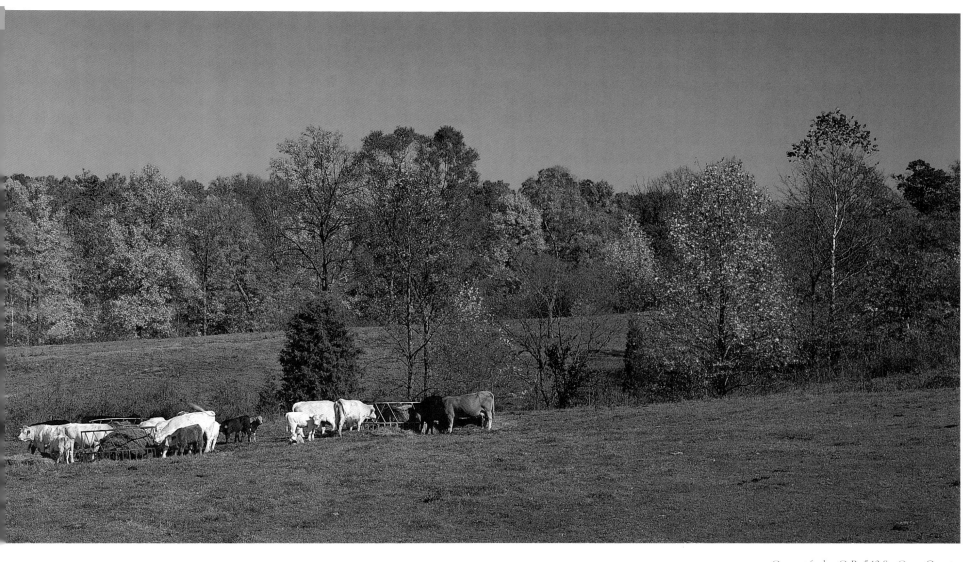

Cows at feeder, C.R. 540 S., Owen County.

Haying has evolved three steps since my boyhood. I remember loose hay pitched by hayfork onto a wagon and thence up into the haymow of a barn, and what a heavenly place a haymow was to hide in, or to lie in and read when there was rain on the tin barn roof, with the hay all soft and sweet-smelling.

Next step was the square bale, and that prickly, itchy, thirsty job of slinging bales up to the man on the wagon, who seemed to be about twenty feet up there catching them.

Now these rolled bales that are both made and carried by machinery seem to be what you see most of these days. They must take most of the exercise out of the job.

But they are picturesque out there in the fields, lying there in the various kinds of weather and daylight—and moonlight, too.

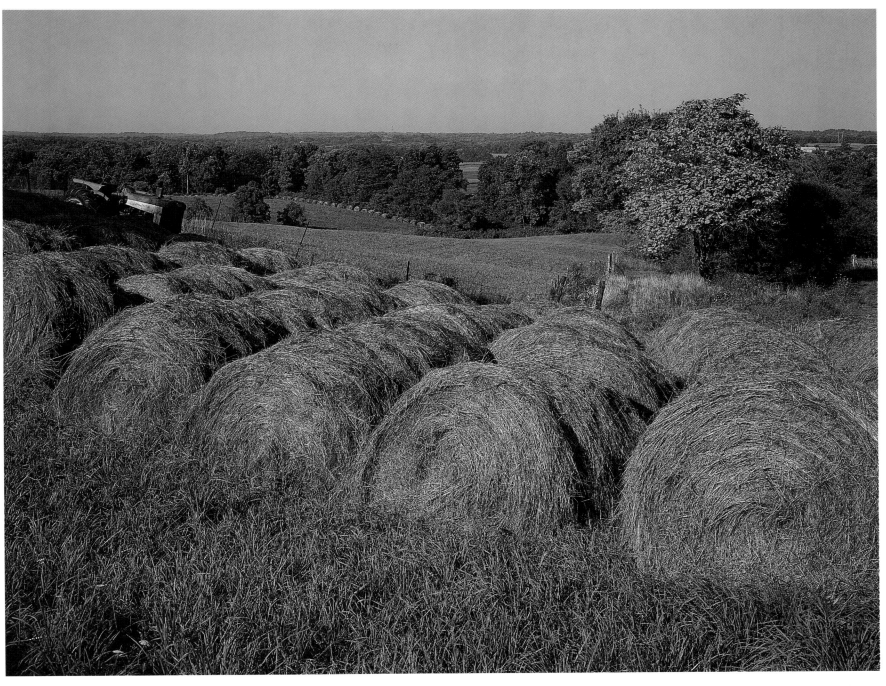

Neatly arranged round bales of hay near C.R. 485 W. and C.R. 140 S., Owen County.

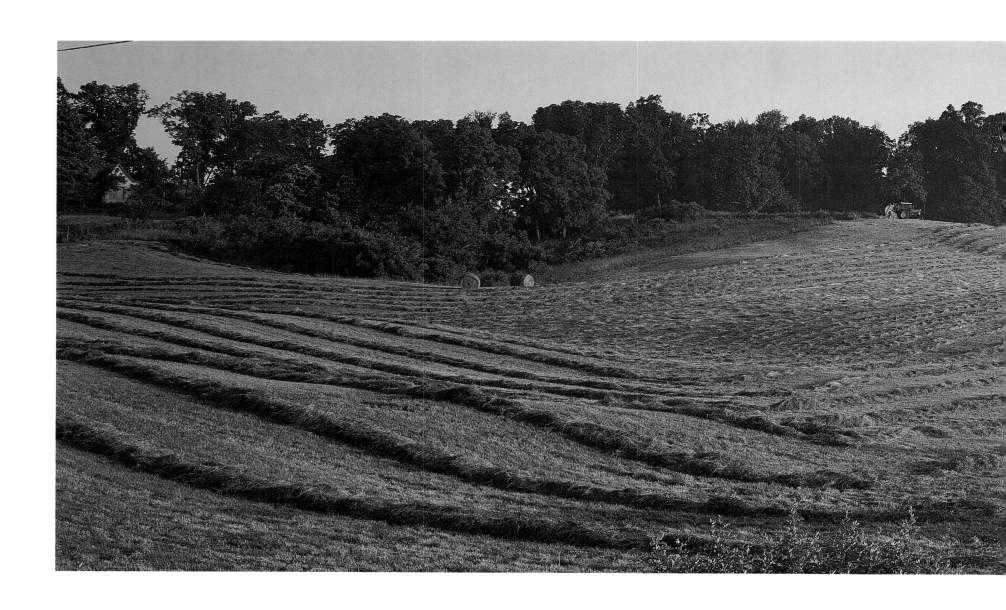

Morning sunlight on freshly cut hay, west of Spencer on S.R. 46, Owen County.

The cut tobacco standing in this field reminds me of old photographs of vast tepee encampments of the Plains Indians late in the last century. Maybe that's appropriate, as tobacco originally was a Native American crop. Some Indians I know smile grimly and call it the Red Man's Revenge.

This part of Indiana is at the edge of Kentucky's vast tobacco lands. And of course so many of the old families in these parts came here from Virginia by way of Kentucky, and in such families tobacco had been a cash crop for generations—as much a habit to grow as to smoke and chew.

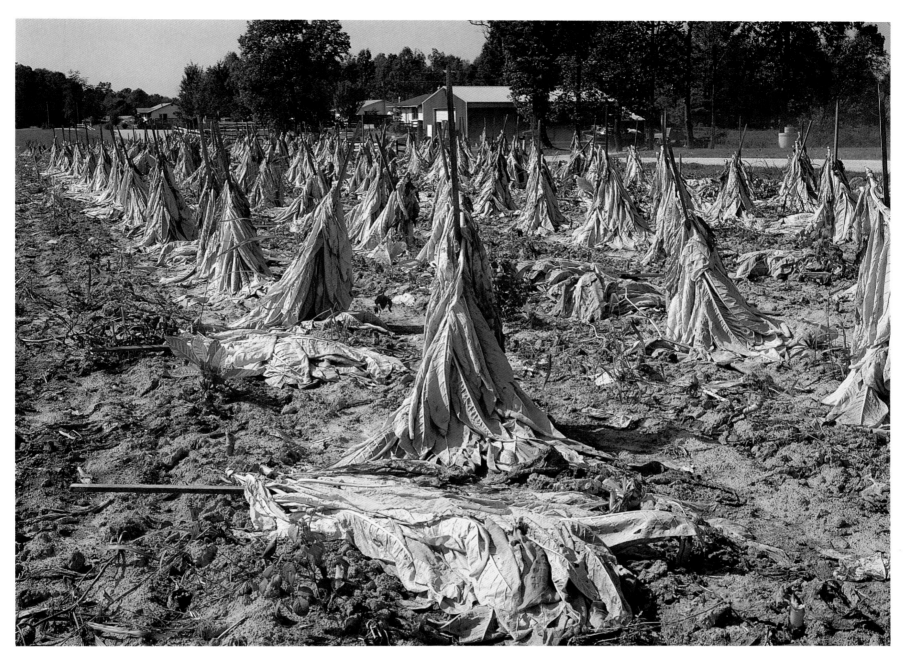

Tobacco drying outside of Metamora, Franklin County.

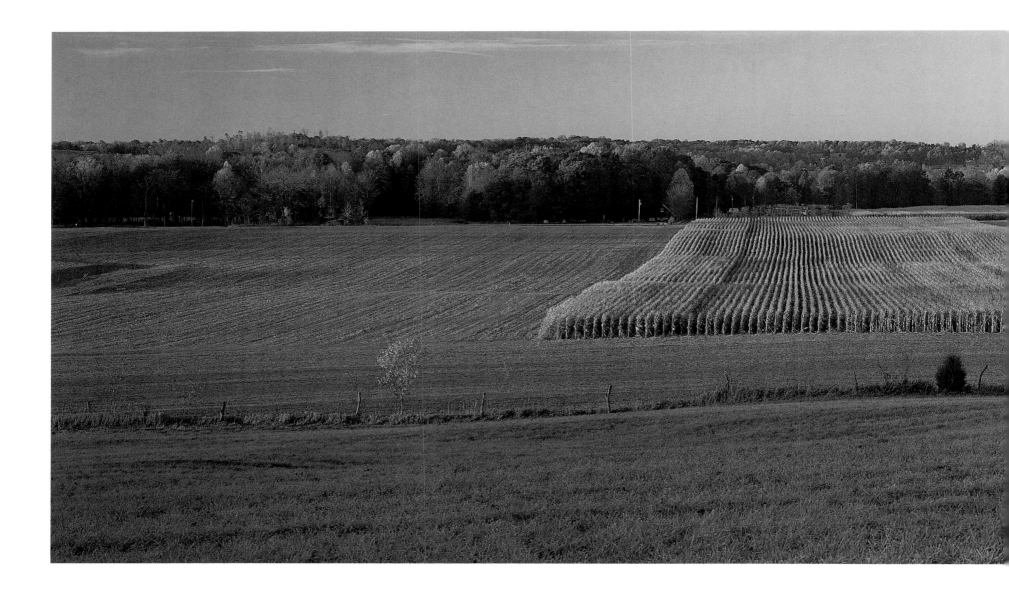

Here is the greatest gift the Native Americans gave to the rest of the world: maize, also known as Indian Corn. This grain, which in its varieties will grow in almost any climate or soil, revolutionized the world's food resources, either by direct human consumption or as livestock feed.

The settlers found a way to give corn back to the Indians. They brewed and distilled it to make whiskey, and taught the Indian to *drink* his corn, thus inventing the "internal combustion Injun" and hastening the downfall of the tribal cultures.

It is true, sometimes cruelly and painfully true, that, as the Indians say, what goes around comes around.

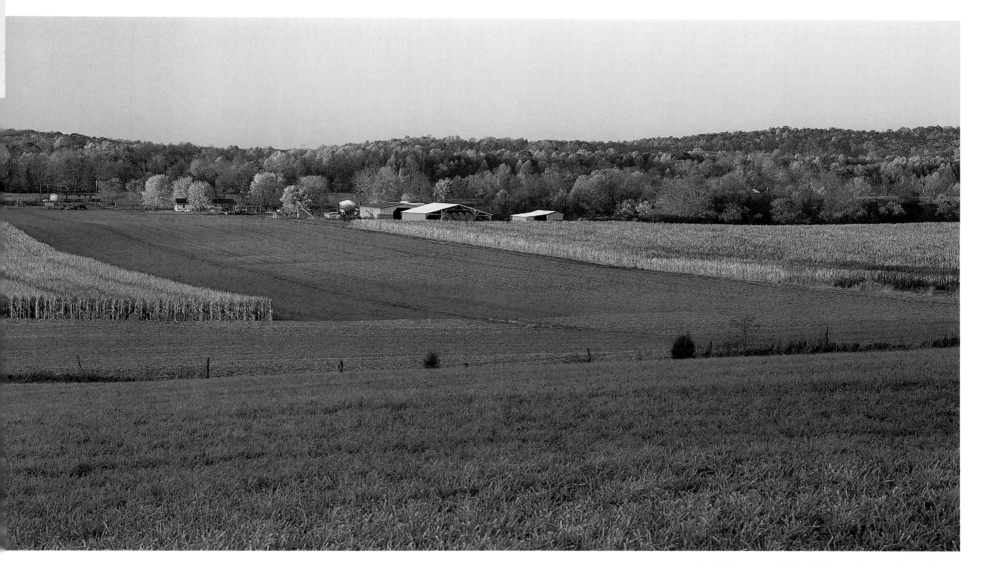

Cornfield at sunset, C.R. 600 S. near Freeman, Owen County.

Nevertheless, corn is a great gift, and it is appropriate that Indiana, "the land of the Indians," is associated in people's minds with corn.

The soil here in the uplands is good for growing corn, but the terrain is limiting, compared with the rest of the state of Indiana.

Many of us Owen County youngsters got a chance to make that comparison way back in the 1940s.

We grew up here where cornfields are planted on bottomlands and slopes tucked away amid the wooded ridges. Every summer we had an opportunity to go up to the big, flat

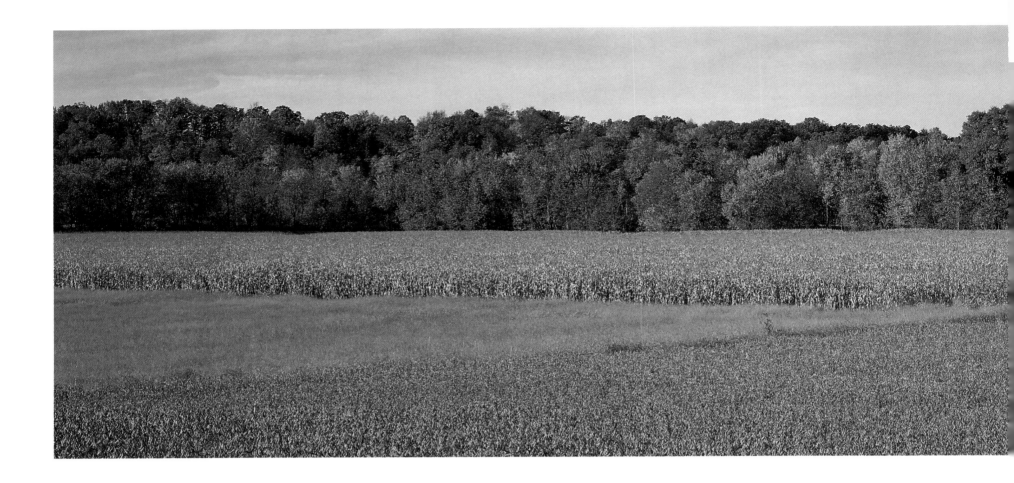

corn country in busloads and work on the hybrid seed corn farms as detasselers. It was as close as we'd want to come to the experience of being migrant farm workers. They'd take us up to big farms near Lafayette.

Our job was to walk down selected rows of corn and remove the tassels so that the pollination of certains stands could be controlled, the result being hybrid seed corn. We bunked in enormous barracks-like sheds. Remembering back over half a century, I'd say there must have been hundreds of us upland kids at work up there, many who'd never been out of our home counties before. Hardly any adolescents had cars in those days.

We must have been pretty well-behaved kids. I remember, though, finding myself in an occasional fistfight. At home I knew pretty well whom to avoid, but there were bullies at large in those corn camps.

I don't recall what system they had for keeping boys and girls segregated, but I seem to remember that they kept me as well protected from the danger of females as the

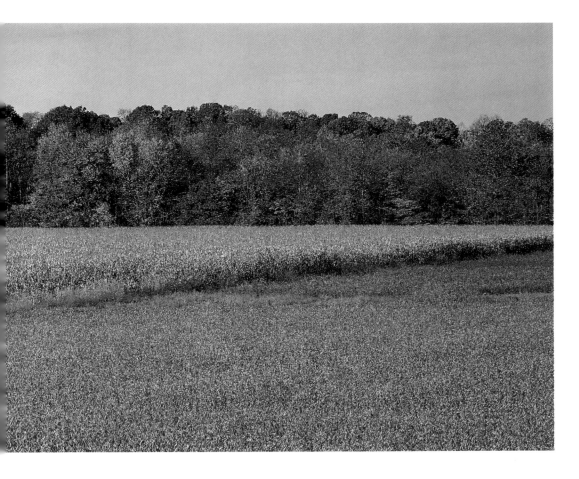

Soybeans and corn before harvesting, S.R. 231,
Near Devore, Owen County.

Marine Corps did a few years later. (But then, come to think of it, those hybrid farmers *were* in the business of preventing unwanted cross-pollination.)

Anyway, detasseling on those vast farms gave some of us our first real sense of what our math teachers called *infinity*. In a cornfield at home you could see a tree-shaded hillside close ahead and know that was the end of the row. But on those seed farms you were over your head in a sea of corn, forever reaching up as far as your hands would reach, squinting into the high, hot sun, with nothing ahead but those same rows of dusty corn extending forever.

Detasseling was a good way to earn a little summer pocket money, but it was a joy to get on those yellow school buses at the end of the season and roll back down into these shady Hoosier hills where there was something beyond the end of the corn besides more corn.

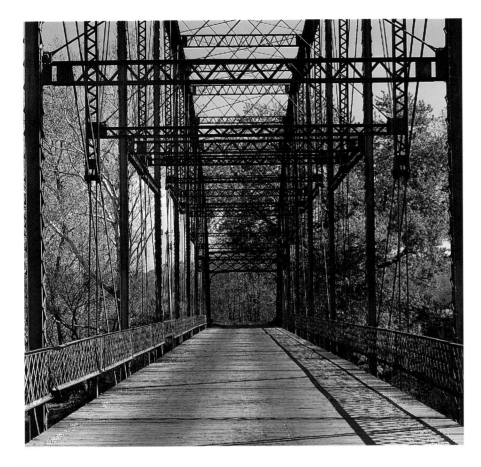

One of two remaining iron bridges spanning White River, built 1898, Freedom, Owen County.

Within memory, I'm sure I have not been down this wagon road.

Prior to that, I'm pretty sure I have.

Here's what I mean.

During the Depression my mother was a country doctor in Owen County. It was before the controversy over whether a woman could combine a career and motherhood. Her office was at home, so she was always nearby when we were there. And when she had to make house calls, she would put her children in the back of the car with a picnic basket and take us from farm to farm. At the end of her rounds she would stop in some scenic place and we'd have a picnic.

Now I can stray down a back road I don't remember having been on before, and experience *deja vu*, or know in advance what's around the next bend.

I probably saw this scene about fifty-five or sixty years ago along the road from one of her rural patients to another. There aren't many parts of Owen County that I didn't first see that way.

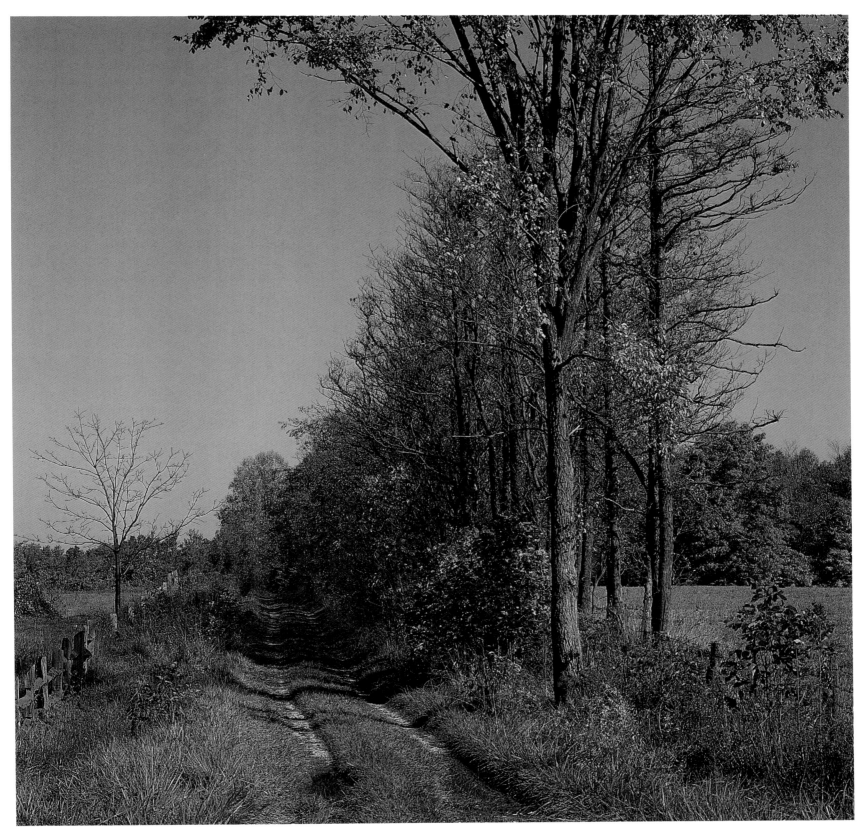

C.R. 900 W. north of Arney, Owen County.

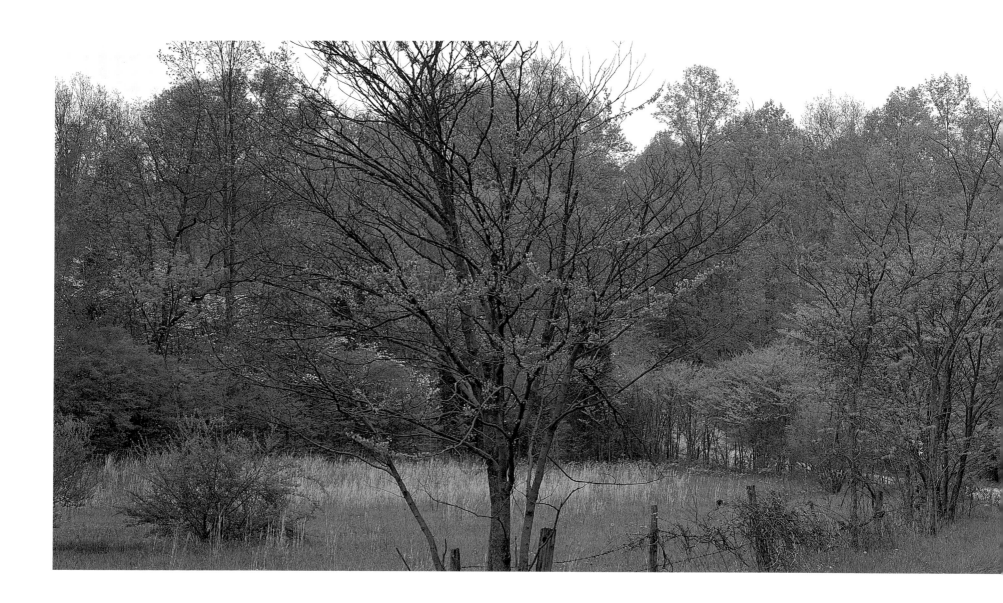

Redbuds along county road near Owen-Putnam State Forest, Owen County.

A straight road may be the shortest distance between two places, but only a highway engineer or a motorist in an undue hurry could find much to love about it.

A road curving away through the countryside is a beautiful and intriguing sight. You can pretty safely guess that God engineered it, first as a path through the terrain for instinctive animals, then as a route for tribes who knew that animals know their way around.

Highway 150 slanting northwestward across Southern Indiana from near Louisville is

Road following contour of land, C.R. 925 W. south of Patricksburg, Owen County.

a grand but almost forgotten example of animals leading the way for roadbuilders. That was once the old Buffalo Trace, a wide road trampled out over the centuries by bison herds migrating between the crossing places at the Falls of the Ohio and the Illinois prairies. Tribes and armies followed it, then, finally, the roadbuilders.

Dynamite and gigantic earthmoving equipment have made it possible to build straighter—and more boring—roads across the terrain.

But I'm not usually in a terrible hurry. Give me a road that meanders through the scenery.

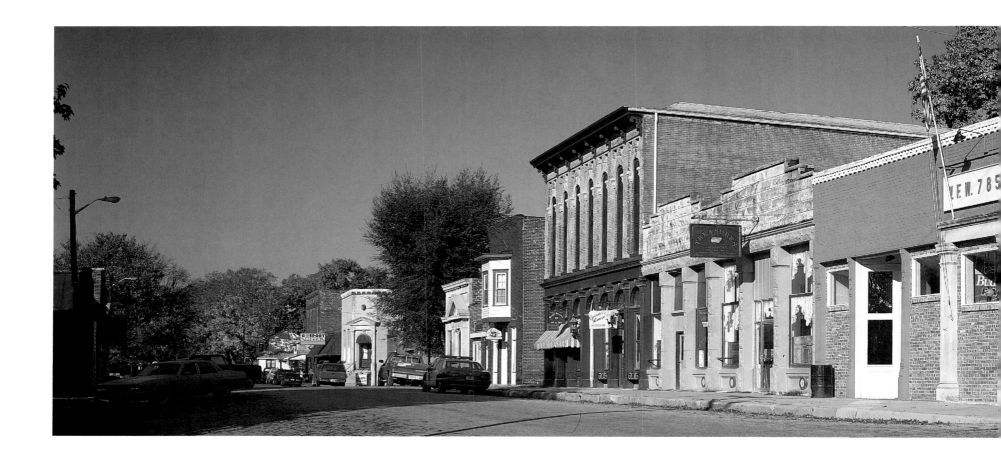

This is Gosport, in eastern Owen County, where I was born during the Depression and spent my first ten years. This is still pretty much the same way I remember the main street.

Remember the old small-town jokes about how the big excitement was to go downtown and watch the stoplight change? Well, Gosport didn't have a stoplight, and you'd have to go clear over to Spencer for that kind of excitement.

My parents were fresh out of medical school and had set up their office in an old house two blocks from this scene, with a sign outside saying DRs THOM. No one had money for doctor visits in those days. Mother would recount later on, "Fortunately for us, the grocer's wife broke her leg soon after we got there, so we could eat."

The pale blue building up the street is the insurance office of John King. He and his brother Joe were schoolmates of mine, and now are among the personalities that keep the spirit of the town strong and lively. Joe has the Gosport Manufacturing Company, which makes tents and tarpaulins and has for a long time been about the only industry

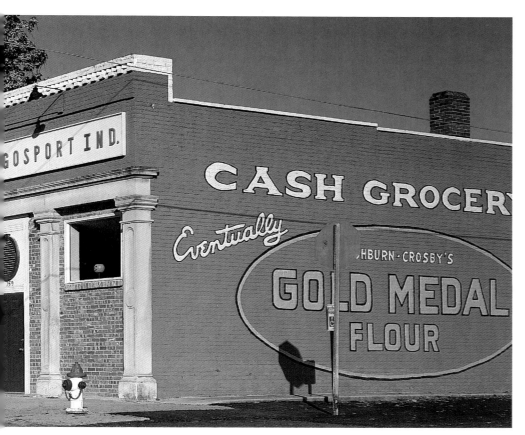

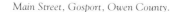
Main Street, Gosport, Owen County.

in town to speak of. That blue building used to be the bank, I remember, and half a block north was the Post Office where we kids bought U.S. Savings Stamps for the War Bond effort. I remember how important that seemed to me, because by then my father was in the Army Medical Corps serving in the Pacific, and I always felt that my Savings Stamps were somehow helping him. We grew Victory Gardens and saved bacon grease for the ammunition factories and had blackout window shades and air raid sirens, and most kids memorized the silhouettes of all enemy aircraft. Back then, old Uncle Sam could make you believe that Messerschmitt fighter planes and Stuka dive-bombers might attack Gosport, Indiana, at any moment. You just wouldn't believe your government would fib or exaggerate. Kids and adults alike found it exciting to believe it might happen, and it kept us all very patriotic through a war that was costing us an awful lot.

So I can remember growing up through a depression and a war in a little Indiana town of about 700 population. This was an entirely different society then, but I and my place still have our continuity with that other time. The roots are still here and still growing.

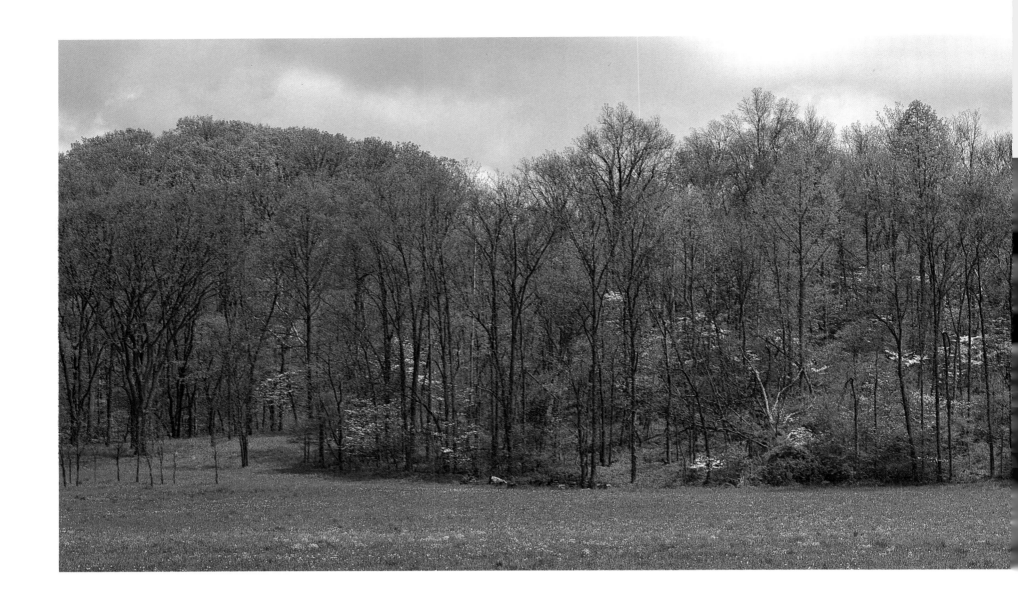

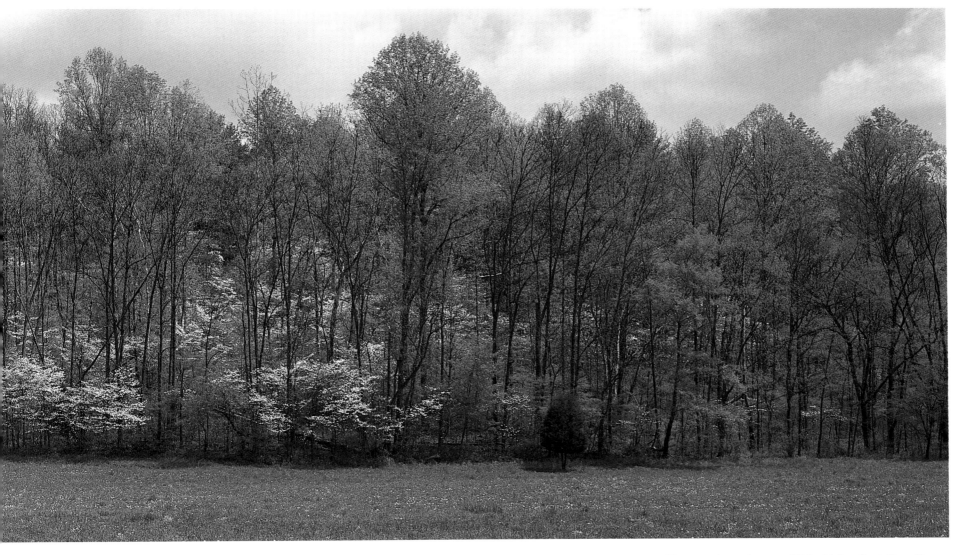

Blossoming dogwood trees on Old Patricksburg Road, Owen County.

These fields and meadows are lovely to look over and walk in, but they are not natural to the uplands. Almost all of what is now Indiana was, less than 200 years ago, so densely wooded with gigantic hardwood trees that early travelers complained of the claustrophobic gloom and lack of any views. We fly or drive over the state now and marvel at how much forest the settlers removed—virtually all of it at one time or another. The history books make much of the superhuman efforts of ax-wielding pioneers clearing the forests of the whole eastern United States by sheer muscle power. Think of cutting down millions of trees whose trunks were five to ten feet in diameter, just by swinging axes! In

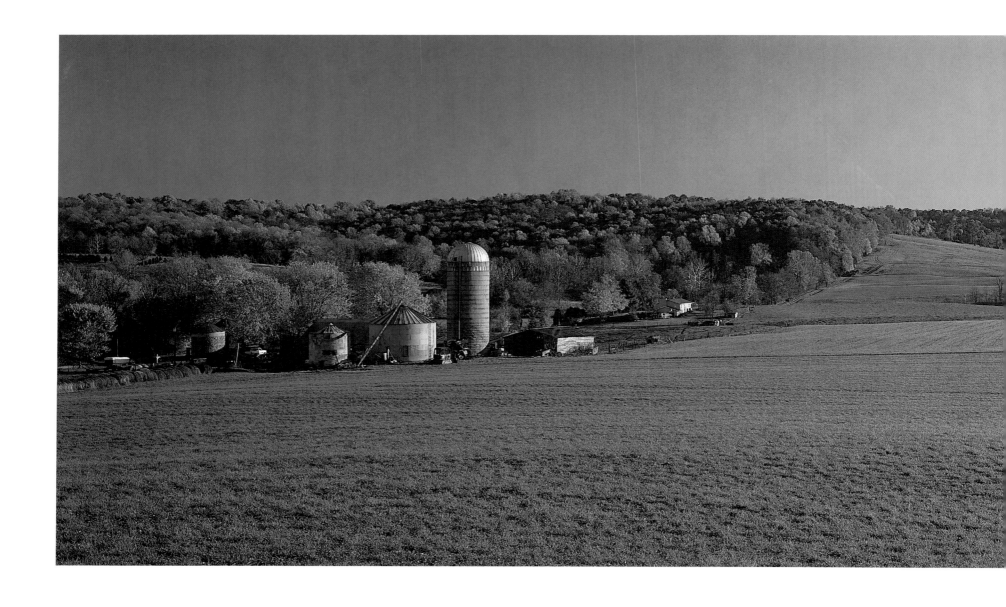

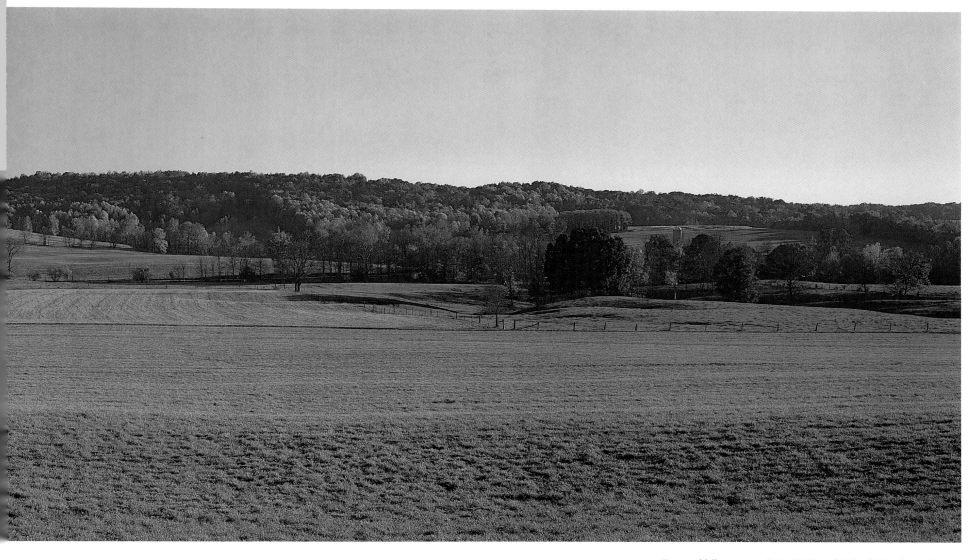

Farm and hills at sunset, C.R. 450 E. and C.R. 450 S., Owen County.

fact, the Great Seal of the State of Indiana shows one of these Paul Bunyanesque pioneers swinging his fabled ax.

Permit me to deflate that myth a little. Although those old-timers did work terribly hard, most of the deforestation of America was done by the energy of slaves and work animals. Most of the trees were not cut down but killed by girdling—cutting the bark all the way around the trunk; later the dead trees fell and rotted or were used for firewood, the stumps being pulled out by oxen or workhorses. Our pioneering forebears were prodigious tree-killers, but they were mere humans.

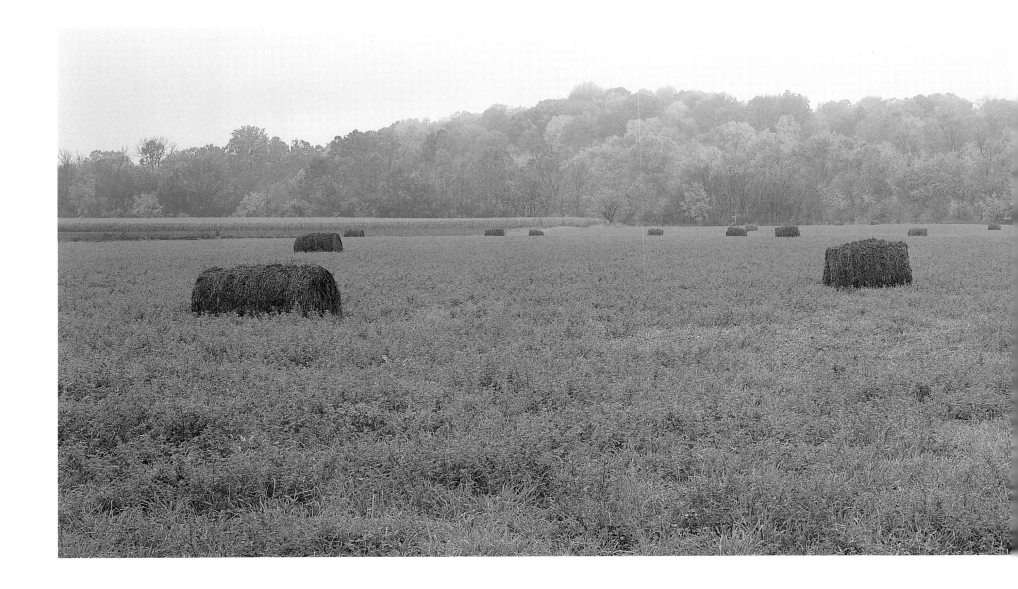

Anyway, they left us with expanses of pasture, meadow, and field, tillable and productive, wide spans of paradise for the birdshooters and horseback riders. Where the trees are gone you can observe the contours of the land and marvel at the many and beautiful varieties of ground cover. In these stretches of tamed landscape the grazing animals become moving components of the scenery. Considering how few horses one sees actually being ridden or worked, there must be thousands of Hoosier hill people who have horses just for decoration—or as grass-mowers.

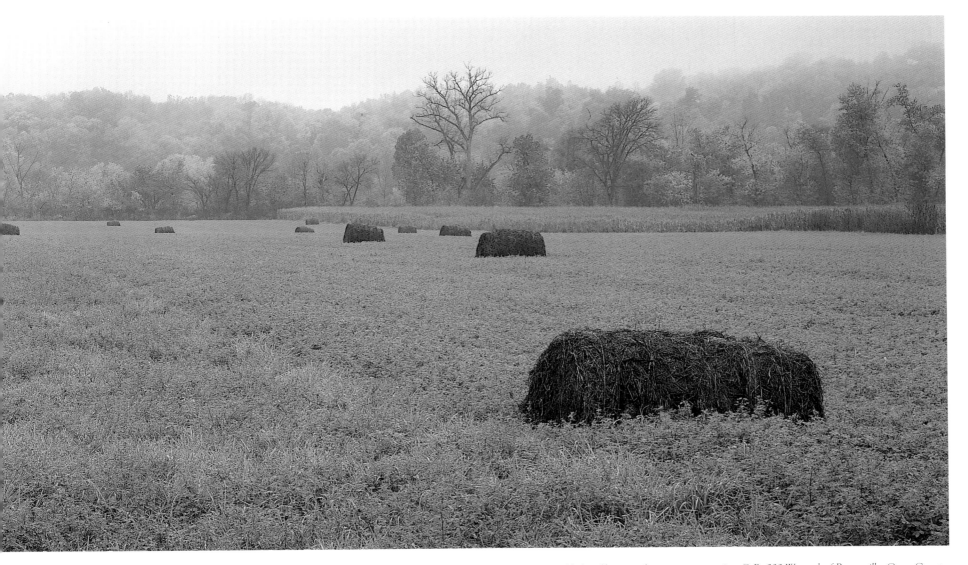

Round bales of hay on a foggy autumn morning, C.R. 200 W. north of Pottersville, Owen County.

Mowed fields look wonderful. Even beyond the need for hay, modern Americans have an obsession with mowing their fields and lawns and roadsides—now that they can do it easily while sitting on a tractor. I do it myself, with a reliable 45-year-old Ford 8N tractor and a bushhog. I go over about 20 acres of my valley and make it look like a park. It is monotonous and noisy and I don't know why I enjoy it. I guess it's just satisfying to keep it looking good because it's my responsibility and it's a part of my view.

There's a coyote who frequents my meadow in the valley. I never see him except when

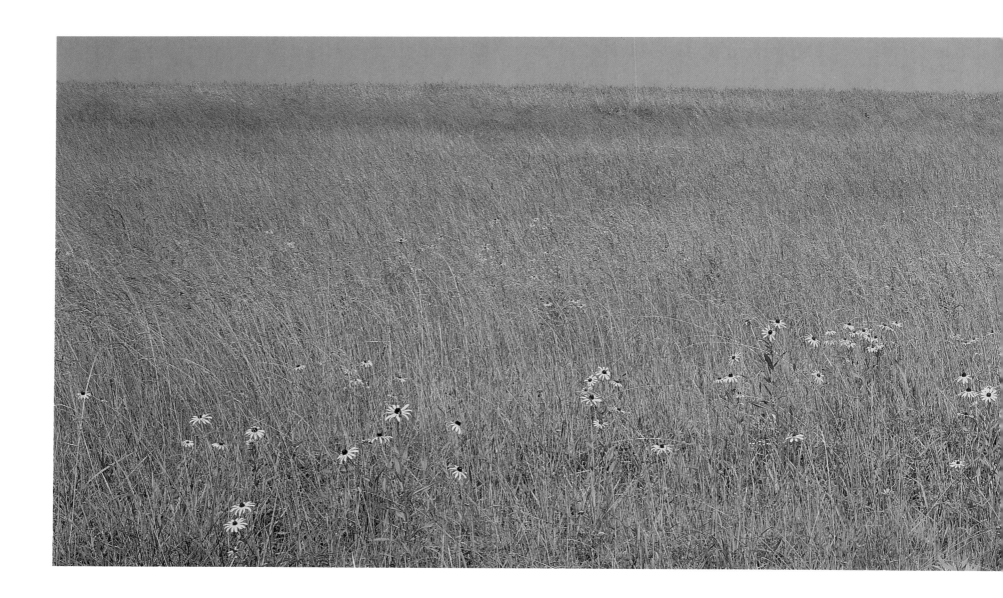

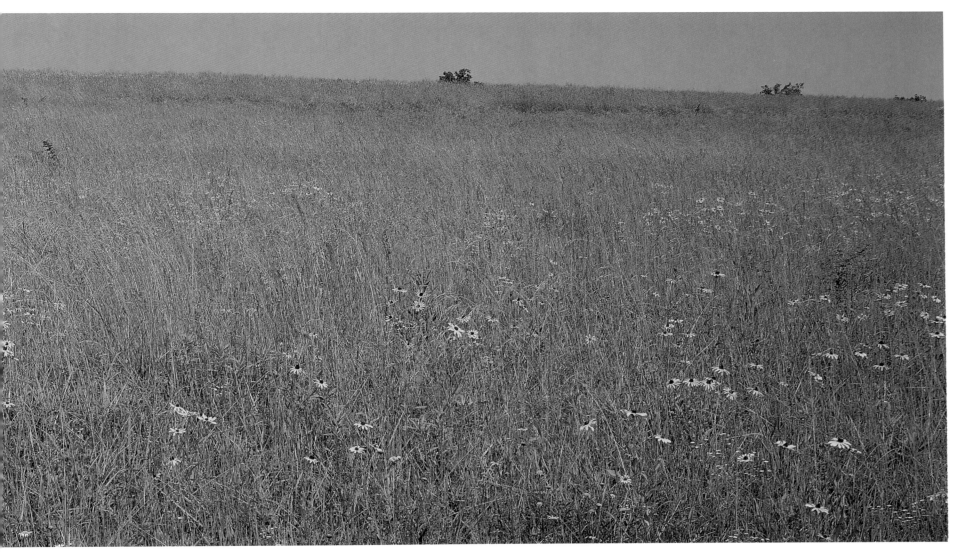

Black-eyed Susans in open field, S.R. 231 near Carp, Owen County.

I'm on the tractor. If I'm walking he won't come out from the woods—I guess because he sees I'm a two-legged. When I'm on the tractor I guess I'm just part of a thing, and even though it's a noisy thing, he has no fear of it and has walked within thirty yards of me.

It's just one of those things you can muse on during the monotony of mowing. . . .

Coyotes are smart. Maybe it's been his experience that a mower stirs up rabbits and shrews and field mice and other goodies and he wants to be near when that happens. I'll ask him next time.

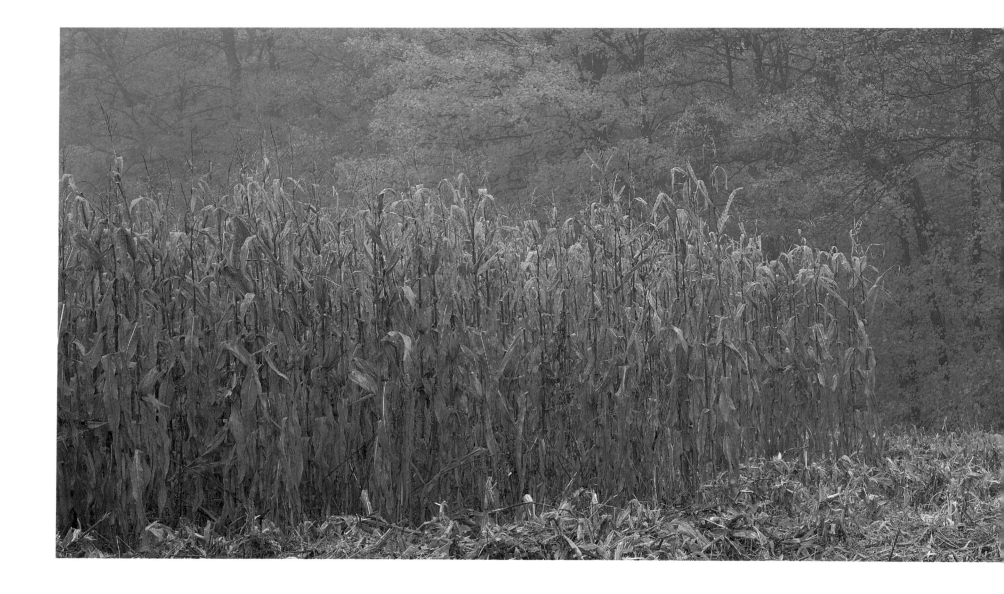

Like any author, God writes some of his most interesting notes in the margins. In rural landscapes, of course, it is humans who make and maintain those margins, and so humans are prominent in those interesting marginal notes.

By margins I mean those places where the woods and the clearings meet: the edges of fields and pastures, the roadsides, the windbreaks, the fencelines that are always being silently reclaimed by scrub. Here is that haunting interplay of light and shade, sundapple, shimmering heat, and delicate breeze. Here is the keenest sense of distance and

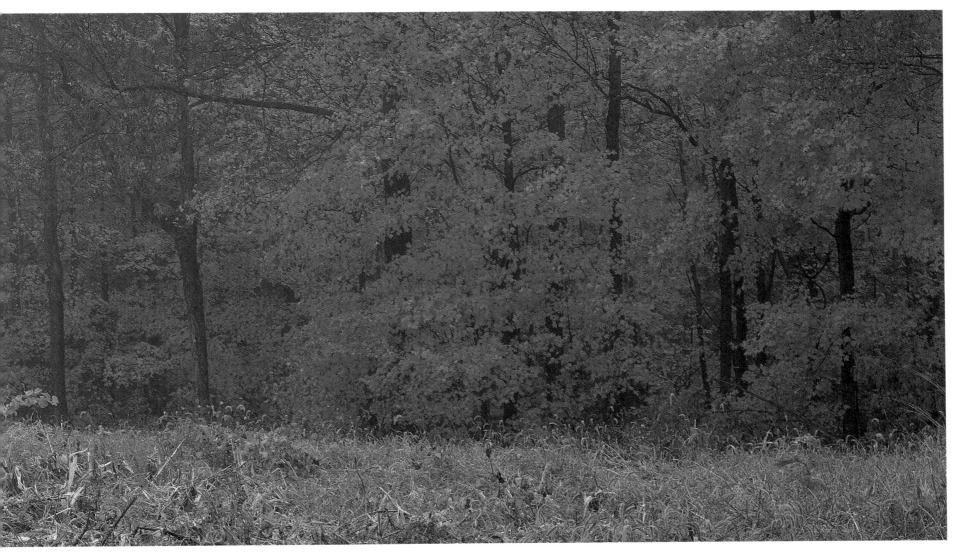

Corn and woods, C.R. 975 W. south of Patricksburg, Owen County.

depth, of dryness and damp. And here is the widest variety of life, both plant and animal. Here the berries burgeon and the timid creatures come to thrive on them, just back of the open fields where they'd feel too exposed to the eyes of hunters and hawks. Here they shelter during the hot glare of day, waiting for dusk. Here is where you'll hear and see the most songbirds. Here is where the gnats and mosquitoes drift out in the evening and the bats flutter about snapping them up.

Here is where in the heat of the day the mower used to lay down his scythe and step

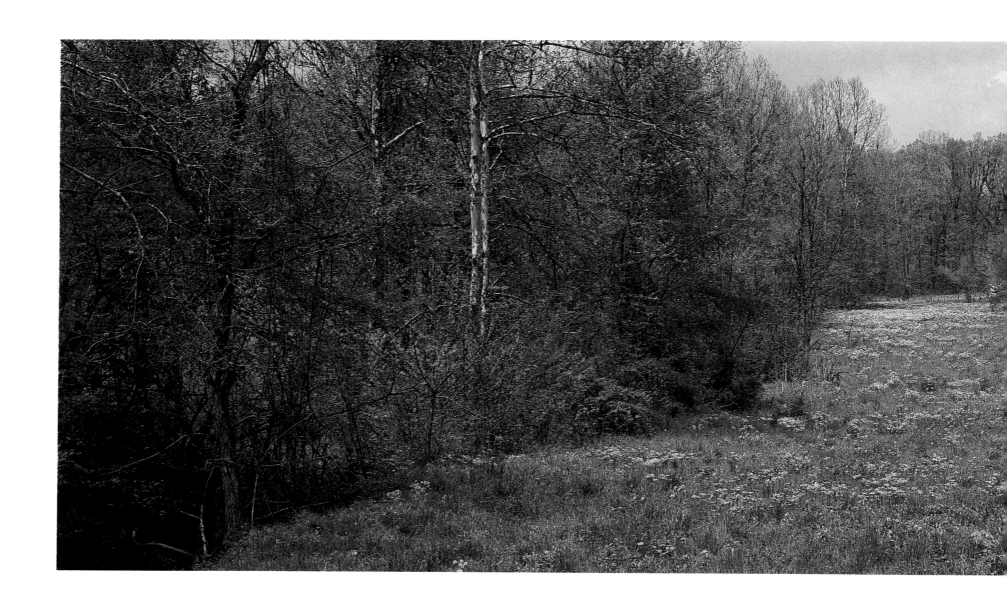

Spring field near Cuba, Owen County.

into the shade to wipe his sweaty face and rest a while before picking up his blade again and trying to keep the margins neat. Nowadays they mow the margins with a noisy, smoky Weedeater. I'm old enough to prefer using a quiet scythe, like the old gent in the true story that follows—a neighbor who symbolized for me the symbiosis of man and place. He was a descendant of Micajah Freeman, the Revolutionary War veteran I mentioned earlier, and this story took place in the margins.

 Little Old Hero

On that fatal summer day when old Mr. Freeman put his scythe on his shoulder and walked down toward the fields, he had no idea he was about to do the last admirable deed in a long life of good work. He thought he was just going down to mow weeds and clear brush, as he had done every year for the last seven decades. His little dog Fanny came along with him, as she always did.

Estel Freeman never let weeds take over any part of his farm. One of his vows in life was, "I'll leave my land better than I found it." That was no idle boast. His farm was a model. The yard around the neat white house never had the sort of clutter in it that mars the beauty of so many Southern Indiana hill farms. The pastures, even up on the steep hillside behind the house, were always trim as a lawn, either through mowing or grazing. The big barn was kept in good repair, and the bottom land along the twisting course of Little Raccoon Creek was always in a fine crop of corn or hay.

Estel's farm was a picture of beauty and efficiency, and that was all the more remarkable because Estel had little use for machinery. He had done almost all his work by the muscle power of his own erect, spare little body or that of his pair of draft horses.

In doing all this, old Estel himself always managed to look as clean and orderly as his farm. Even when his faded cloth cap was sweaty around the band and his overalls were mud-caked to the knees, he somehow looked clean and dry and cool. On the hottest days behind the plow, he kept the top button of his blue work shirt fastened. His tanned, thin-lipped pioneer's face always was calm and resolute. He looked to be a man with not a fear in his heart or a sin on his conscience. He was 83 and still busy.

Estel had been farming this place with horse teams since he was 12 and believed that he had thus avoided the mistake that keeps so many small farmers in debt: expensive farm equipment. Much of his serenity stemmed from his religious faith, but some of it was because his domain was not mortgaged for farm machinery.

"It's true you could plow and harrow this field faster with a tractor than I can with my team," he would tell a visitor while caressing the jaws of his Belgians. "But Mike and John here, they can be out working with me early in the spring when it's still too muddy for a tractor. So it comes out about even. I get my crops planted about the same time I would if I used a tractor. But I don't have to worry about the bank the way a man with a tractor does. And," he'd chuckle, "I grow my own fuel too."

He admitted that it grew harder and harder to farm by horse team. His old hands were full of pain and it hurt to control those powerful beasts by fistfuls of leather reins. But he still did most of his chores with hand tools.

Now on this final day, Estel unshouldered his scythe at the base of a big tree. He tested its whetted edge with his thumb, nodded with satisfaction, looked around to make sure that the dog Fanny wasn't too near the path of that long blade and saw that she was nosing about a little way off. She was the latest in a long sequence of dogs he had outlived. He always named them Fanny.

He took the nib-handles in his arthritic brown hands and began mowing around the base of the tree with the skill of years, an easy-going, rhythmic, twisting swing, developed of necessity by a man who had done the work of a dozen farm machines though he had never weighed much more than 130 pounds.

The blade hissed; weeds fell; their rank greenish smell enveloped him. Locusts shrilled under the hot sky, and Estel breathed in time with his labors and watched the progress of his keen blade.

"I keep a tool sharp. A dull tool makes a hard job," he would always say. And he would raise whatever tool he had been using—scythe, hoe, axe, sickle—and show its shiny, razor-sharp edge, and likely then he'd offer a brief discourse on angle, grinding, honing, tempering.

He loved to tell anecdotes, ranging back over half a century, about how he had learned to do things efficiently: cut a tree so it would fall just where he meant it to, haul timber out of the woods, lay snug flooring, repair harness. "I've always given at least a dollar's worth of work for a dollar pay," he would state, and that would be as proud as he would ever talk. He would give his quiet lessons and insights with a twinkle in his blue eyes and a nod of satisfaction. He was never too busy to talk to anyone, even a stranger,

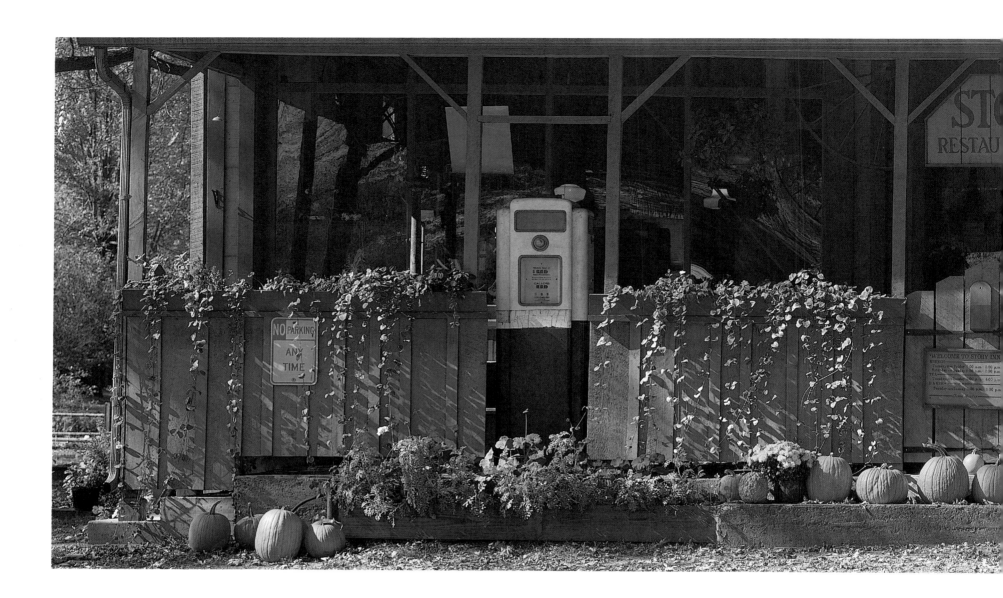

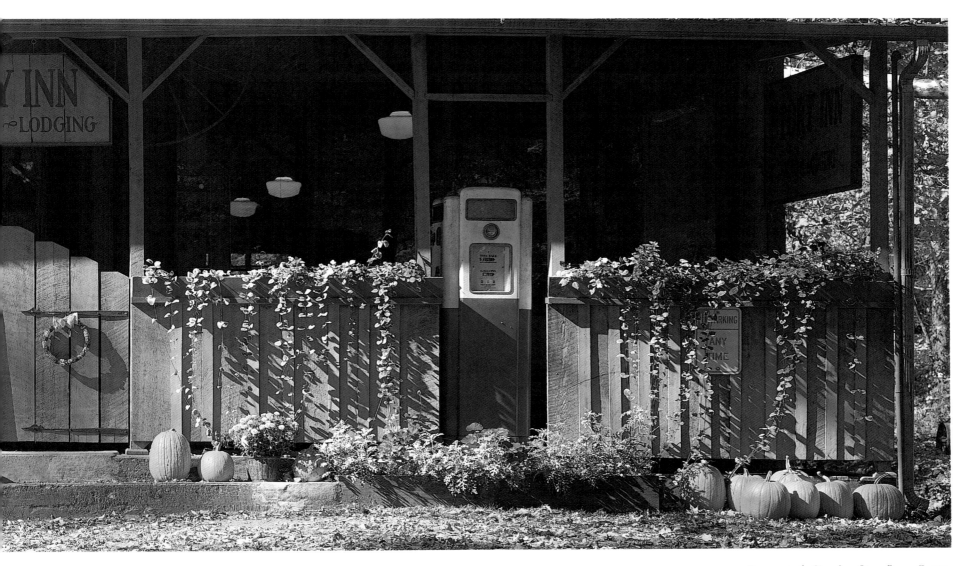

Entrance to the Story Inn, Story, Brown County.

about work and tools and animals, and about living up to his God's expectations.

Even if he was in the middle of a seemingly overwhelming task—like weeding an entire five-acre cornfield with his hoe—he would take time to walk a visitor up to the house and show his favorite hospitality: a drink of his good well water from a porcelained dipper. "I've never had a drop of liquor in my life," he would say after he got to know the visitor a little. "And I've never been in bed with any woman but my wife." He didn't say these things in a pious tone. It was as if he was thankful for having been guided clear of such transgressions as keep so many folks in trouble.

Word of a man like Estel Freeman gets around, and by the time he was 70 or so, he had become something of a local celebrity, frequent subject of newspaper photo-feature stories, an admirable anachronism. Reporters from the region would come and interview him, take pictures of him with his team of horses, his hand tools, his spanking-clean buckboard wagon. He always satisfied their curiosity with patient grace. He never smirked at their town-bred naïveté about horses or tools, or their odd questions about what they called his "lifestyle," though he must have been amused sometimes.

And he was quotable:

On age: "An old fellow told me th' other day, said, 'Estel, I can still work as hard as I did fifty years ago.' I told him, 'So can I, but I don't get near as much done!' Heh, heh!"

Or on his horses: "I treat my team well and they do me the same. After a winter, I work 'em just a little a day, a little more, so they'll be good and fit by plowing time. When my teams get too old to work, I retire 'em, and I go down to the Amish. Those people breed good horses, and they're more honest than most horse traders, I'll say. Yep, I do admire those Amishmen. . . ." Mike and John would stand patiently in their harness nearby, swishing their tails, while Estel in his soft voice gave the reporters plenty to write down.

Perhaps the high point of all Estel's unsought publicity came in 1976, when a magnificent two-page color photo of him behind his team, and several paragraphs of his plain wisdom, appeared in the *National Geographic* magazine.

"People ask me how I plow such a straight furrow," he liked to say near the end of an interview. "I just tell them what it says in the Bible: Take the reins and don't look back." And then with a little smile he would flick the reins and cluck his tongue, and the interview would be over.

But even journalists didn't disrupt the slow, cyclical rhythms of his life, and every summer when the corn was tall enough to take care of itself, he would take his scythe and move down along the fencerows and trees like this, trimming up the weedy edges of his domain.

The blade swished. The hot weeds fell down. The little dog Fanny nosed ahead. There was no warning.

Suddenly Estel saw the blurry honeybees swarming out of the brush and heard their deep, angry drone. He jerked back his scythe. Brushing at himself, he ran from the tree.

The farther he got from their tree, the fewer of the little furies there were about him. They seemed to be drawing off. It had been a close call, but Estel had gotten out unstung.

It was then that he heard the agonized yips of his little dog, over by the tree. Fanny was on the ground, thrashing, rolling, yelping, the target of the swarm's murderous rage.

And so, little old Estel Freeman, being the man he was, dropped his scythe and plunged back into the humming swarm to rescue his little dog. He felt hot, sharp stings on his temples, more through his shirt. But he beat the bees away and carried Fanny to safety.

Estel was buried a few days later, dead of complications from bee stings, having given his life to save a dog's, at an age when most men have just given up on life.

Many folks who love maple syrup and maple sugar, and consider them to be the Ambrosia of the Gods, have never really made them; however, they have read articles about maple sugaring and thus have done it vicariously. I was like that for many years, and what I vividly imagined was trudging through snow carrying sap buckets, and the fragrant steam of the boiling. I presumed it would, like all productive work, produce a good fatigue and that the rewards would be a delicious taste of the product and then surely a deep sleep.

When I got around to doing it myself I found out that the main sensory experience of it was the cutting of wood and the tending of the fire. It does take many gallons of sap to make a gallon of syrup, but the real job is keeping those hot, steady fires going under the evaporators. Dry hickory does the best.

And when you're done, you do have that delicious syrup and sugar, and you do have that well-earned fatigue, but you also have clothes that are utterly permeated with the smell of woodsmoke.

I usually don't get around to maple sugaring any more because of my schedule, and I miss the doing of it—but I don't do without the product. My sister usually gives me a jug of syrup for Christmas. And my good neighbors the Stogsdills never fail to come by and leave off a jar or two from the batch they make at their sugaring shack farther along the ridge.

Maple sweetening proves out the theory that the best gifts to give are the ones you've put much of yourself into.

Open field and woods, C.R. 200 S. north of Arney, Owen County.

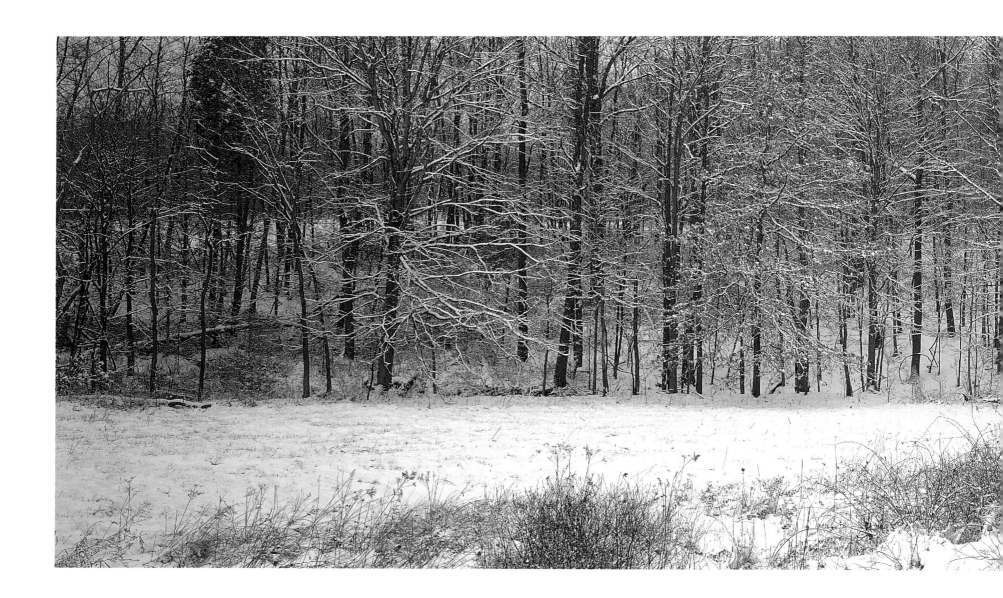

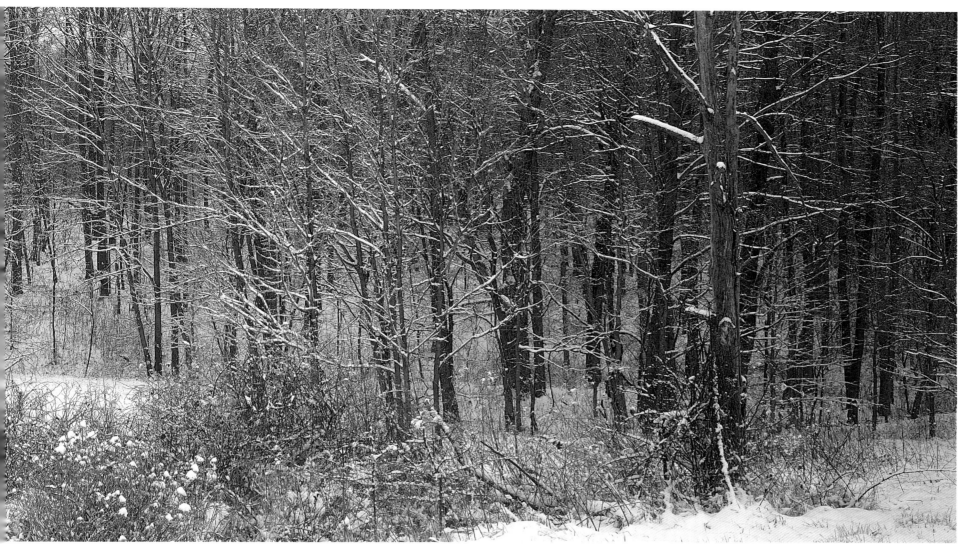

Fresh snow on bare trees north of Freedom, Owen County.

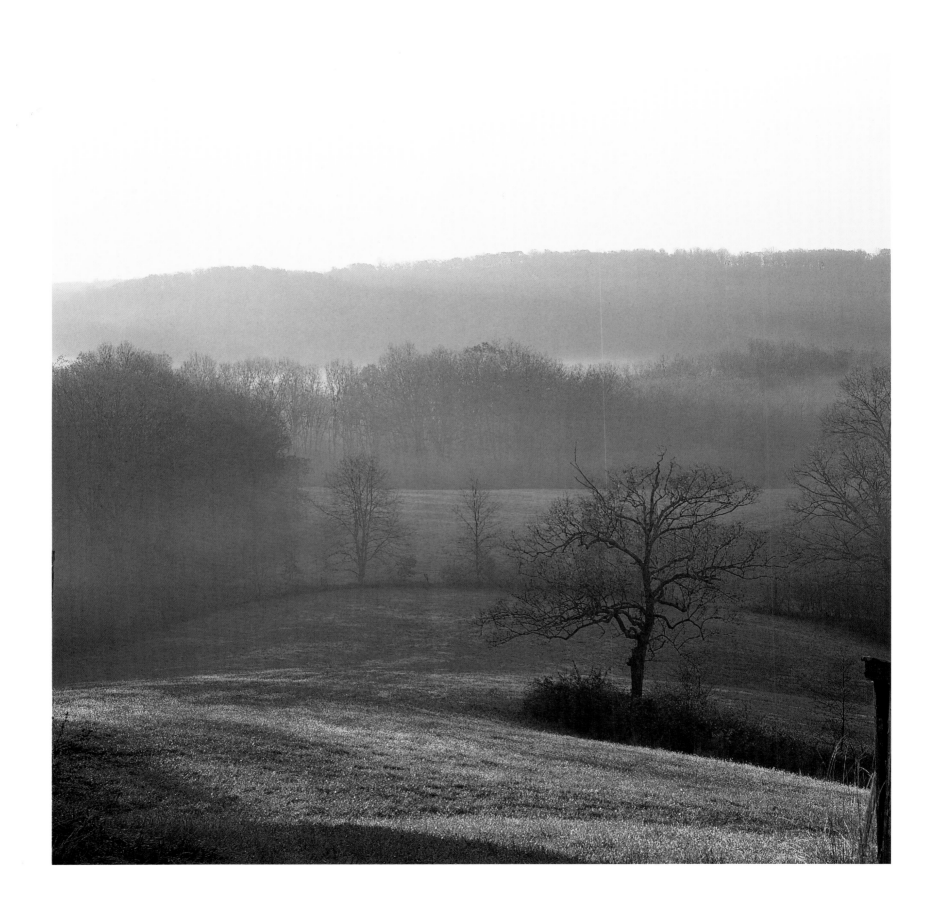

One thing I have long admired about Darryl Jones's photography is his use of light and haze. He is one of the connoisseurs of that special pastel light-veil that hangs over the distant hills.

Famous among such connoisseurs of Hoosier Haze were the American Impressionist painters who colonized Brown County early in the century, led by T. C. Steele.

I have always had a strong empathy for T. C. Steele, even though he lived and died before I was born.

Like me, Steele was a Gosport native who took an odyssey to less desirable places, including Indianapolis and Chicago, then as a middle-aged man returned to these Hoosier hills and built his final home on a windswept ridge with a long, beautiful view. Here in the hills he did the work for which he was best known, capturing the terrain and the light and the very spirit of being here. That soft bluish haze that has earned these hills the nickname "Little Smokies" became the trademark of his landscapes. You can gaze at a Steele landscape painting and feel the autumn sunshine and smell the woodsmoke and sense the steepness of the ground under your feet. He was a man who spent his time outdoors in these hills, and when you look at his paintings you say, "Here was a man who knew the country. His roots were here." When he died in 1926 his ashes were left on the ridge he had chosen.

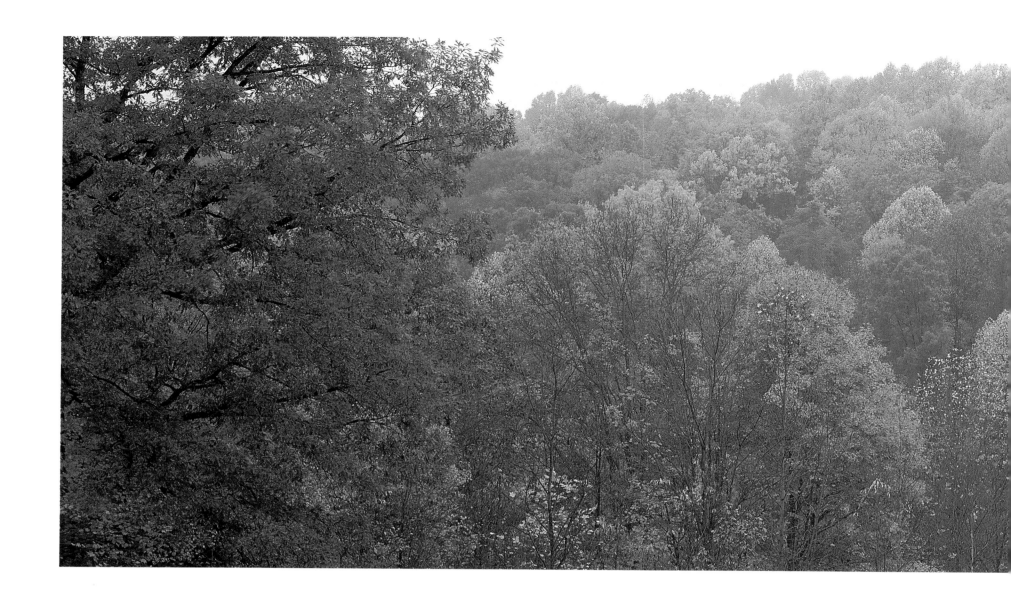

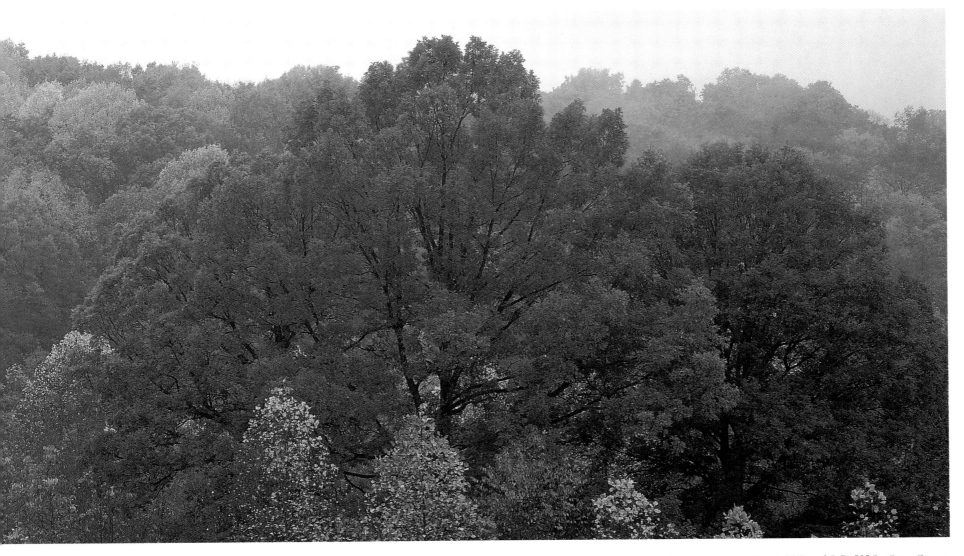

Fog and fall colors, hills at corner of C.R. 75 E. and C.R. 525 S., Owen County.

Something else I can sense as I look out over the county from this ridge—particularly at night when the distant farm lights twinkle to show were people live—is the interweaving of lives. People in a thinly settled area like this are connected to an uncommon proportion of the other people, in varying degrees of closeness: family relations, church members, co-workers, customers, neighbors, old schoolmates, and so on. And then there are those who have nothing in common except that their paths have crossed and something came of it.

To show what I mean by that last statement, I'd like to tell another true story. This took place in Owen County during World War II, probably right about 1943. I didn't get to know the family well until a few years later. Sam, who is the boy in this story, told me the story about forty years later, and that was about twelve years ago, but here it is as I remember it, and knowing Sam and his dad as I did, I'd say this is surely just about how it was, even though I wasn't an eyewitness.

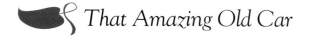 *That Amazing Old Car*

Sam stood in the doorway and cracked his knuckles and cleared his throat, working up nerve to ask his dad for permission to borrow his amazing old car. Old Frank was fairly generous in most ways, but he was a stickler about keeping his sons out from behind the wheel of that danged wonderful car.

"Hell, it's the only good thing I own," Frank would usually growl. "Y'think I want some damfool kids tearin' up gravel roads in it?"

But Sam had to ask because he needed it. It was the family's only car, Sam had something very important to do in town the next day, and town was four miles away. So he took a deep breath and went out into the twilight.

His dad looked mellow enough. He was standing in the side yard next to the car, one huge hand grasping the bib of his sawdust-powdered overalls. Between the thumb and forefinger of his other hand was the butt of a hand-rolled Bull Durham cigarette. Fireflies were starting to wink over the meadow, and the roof of that old square black sedan had a rosy streak of sunset afterglow reflected in it. Frank wasn't looking directly at the car,

but anybody in the family knew that what he was doing was appreciating the only good thing he owned. He and that steadfast car of his were communing with each other in the silence of the evening. The evening breeze brought the greasy smell of frying jowl bacon across the yard, then a whiff of baking biscuits.

Sam walked quietly over and stood near his dad. "Hi, Pa."

Frank sucked on his smoke. "Howdy, boy." His voice was a sort of gurgling rumble. All his life he had breathed earth dust and hay dust and coal mine dust and quarry dust and cigarette smoke instead of air, so he sounded as rough as he looked.

"Pa, I . . ."

"Say, Sam, I'm as dry as a popcorn fart. Why don't you go down to th' spring house and fetch me a bottle of beer?"

"Sure, Pa. Uh, but could I ask you a favor?"

"Fetch that first. I'm dry as an Arizona road apple."

So Sam went and fetched it, and stood there while Frank opened the bottle-opener blade of his pocket knife and pried the cap off. Frank put his knife away and handed the bottle cap to Sam, saying, "There, you sniff that, and maybe it'll satisfy you till you're old enough to drink one. Now what's your question?" He tipped the bottle up and took a long pull. He swallowed, smacked his lips, and belched. By the age of sixty, Frank had built himself a large, sloping beer belly. His back was straight, and his shoulders, neck, and arms were thick and powerful. His four strapping, mischievous sons all respected his strength. At various times he had thrown them all to earth like flour sacks when they had needed to be shown that he was still the master of his acre. Frank expected his sons to be industrious, brave, honest, and respectful and to treat their mother like a queen. Old Frank hadn't been able to give her as genteel a life as he'd wanted to, because of the Depression, but he had managed to find quarry and millwright carpentry work part of every year, and with that and hunting and the garden, they had always gotten along. She was a gentle woman with an angel smile, and without Frank's discipline those boys might have been too much for her.

"What I wanted to know, Pa, was, uhm, I wondered if I could use your car to do some things in town tomorrow. It's awful important."

Sam heard his dad's long, exasperated inhalation, as he had expected to. Old Frank said, "What's so damned awful important?"

"Well, you know Ma's birthday's next week. And you know that, uhm, comb-and-brush set she always stops and looks at there at Moss & Money's?" Frank turned his head to look at Sam over the rims of his bifocals. "Well," Sam went on, "I mowed fencerows

The general store at Cataract, Owen County.

for Mister Livingston this week and I've saved up enough to get it for her. You know, the one with the mother-of-pearl or whatever they call it set into the wood?"

Frank took a shorter drink from his beer bottle. "Sure I know which one. I been wantin' to get her that myself for a year. But I can't get far enough ahead." He twirled his beer bottle, frowning at it, knowing it was the main reason he couldn't afford the birthday gift. He sighed and said to Sam, "You sure you got enough?"

"Yeah. I been puttin' away most of my trappin' money, and now with this, I got enough for it."

"And enough for gas? Every time I do let one o' you galoots use my car, you coast home runnin' on fumes."

"Enough for a whole fill-up, I reckon. And oil too, if it needs it."

"Hell," Frank said, casting a loving look at the beautiful old sedan, "that thing don't never burn no oil."

"Well, if it did need any, I could put it in," Sam shrugged.

"Hell, boy, maybe I should hit you up for a loan. Maybe you could afford a can o' Turtle Wax and could polish it up afterwards if I let you use it."

"That's a deal, Pa."

"Promise me you ain't gonna skid slaunchwise around corners? And no pecker tracks on the upholstery, either, damn it."

Sam laughed. "Fancy me gettin' *that* lucky!"

"Well, y' never know. Good things comes to them as deserves 'em. Bad things, likewise, such as syph and clap. Or a kick in the ass if you use my car for a cathouse."

Sam was starting to laugh and blush so hard he could hardly talk. "Dang it, Pa, I don't make *that* much money swinging a scythe for ol' Skinflint Livingston!"

The cowbell outside the kitchen door clanged, and a lilting voice called, "Frank! Boys! Supper's on the board!"

Frank drained the last of his beer, took a last look at his car in the deepening dusk, then started for the kitchen. "Get up early, then," he said, "and ride with me over to the junction where I catch my car pool. Then be back there by six p.m. when they drop me off. And I don't mean two minutes after six, either, I mean six. And don't mention this deal to your brothers, or they'll want to pile in and then I *know* I'd never get my car back in one piece."

That amazing old car that Frank cherished so much was a black 1930 sedan, thirteen years old now, but it still looked and ran like brand new. As he boasted, it hardly burned any oil. It got incredible gas mileage. It just ran on and on, year after year, hardly ever

needing lubrication or new plugs or tune-ups or oil changes. Why, that danged car even seemed to keep itself clean, except for road dust. It really was an amazing car. Frank didn't question his good luck. As he said, good things came to those as deserved them. Frank was no goody-goody, but he was an honest and hard-working man, and so why shouldn't the Powers That Be reward him with an honest and hard-working car? It was a satisfying way to think about it. Frank had got it cheap at a Depression auction, almost new, and it was still almost new after thirteen years, which was a good thing, because Frank couldn't have afforded car trouble.

So Sam got up early with his dad the next morning. His mother served them biscuits and red-eye gravy and coffee, and got evasive answers when she kept asking Sam why he was going to Spencer.

At daybreak Frank started up the sedan and Sam got in, and Frank drove carefully along the gravel county roads to the Highway 67 junction, across the road from the Roadside Cafe & Garage. That was where Frank always met the other carpenters in his car pool. The war's gas rationing had given rise to car pools all over the countryside. Frank pulled the car off to the side of the road where he always parked it in the shade, got out with his lunch bucket, waved at the car full of carpenters while Sam slid over behind the steering wheel, and warned, "Now, you be here at six sharp, and don't drive like no damfool."

"I'll be real careful, Pa."

"Sure wish *I* could afford to buy her that hairbrush."

Then he waddled over to the other car, got in and pulled the door shut, and the carpenters roared off up Highway 67. Sam waved, and then, as he started to shift into gear, a voice spoke beside him. "You're old Frank's boy, ain't you?"

Startled, he looked up and saw the owner of the Roadside Cafe & Garage standing beside the car.

"That's right, sir," Sam replied.

The man leaned with his elbows on the edge of the open car window and tilted his head in the direction the carpenters had gone. "Ol' Frank's a good ol' boy," the man said.

"Yep, he is," Sam replied, happy to hear that but wondering what this fellow was getting at. He was a little wary of a man who would sneak up to your car window and then start buttering you up.

"Yeah," the stranger mused. "Ol' Frank's rough as a cob. Hell of a carpenter, though."

"Yeah, he keeps in work," Sam said.

"Guess he just can't stand to see a thing done sloppy," said the man. "Heh, heh!" He

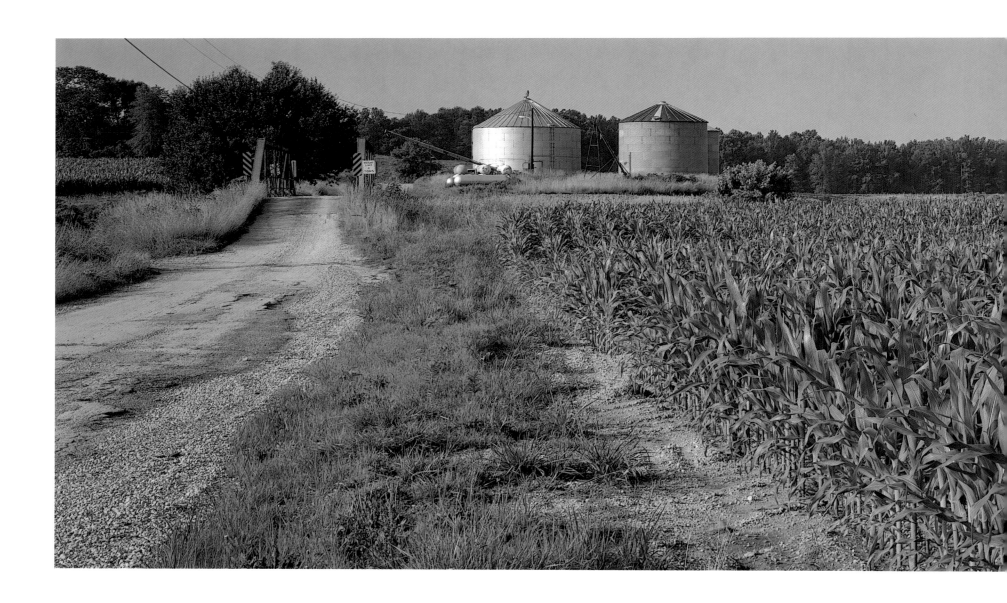

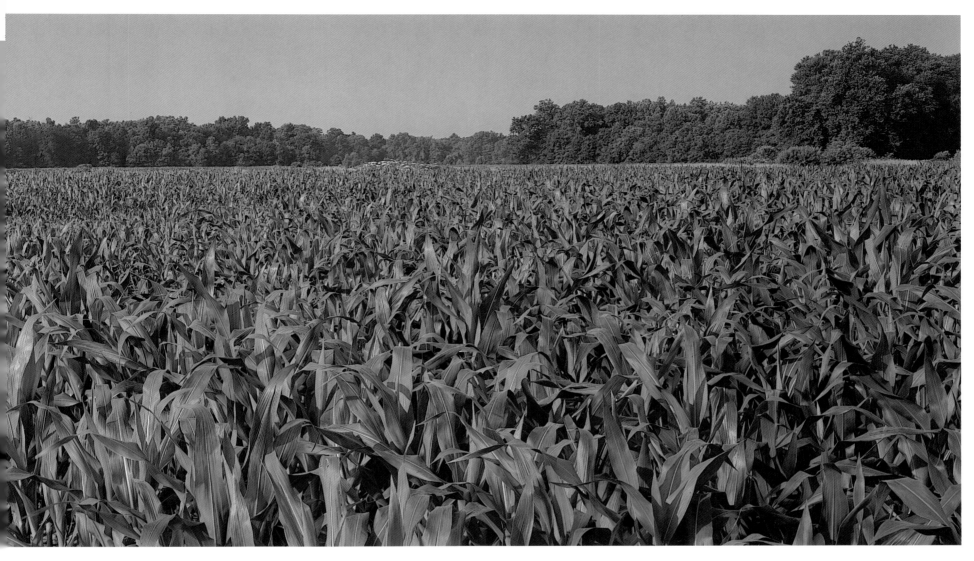

Corn in early summer, C.R. 550 W. near C.R. 250 S., Owen County.

jerked his thumb over his shoulder toward his cafe. "Few years back, we was addin' to this here building. Your pa was comin' home from work and seen us tryin' to hang that side door there. He ambles over an' says, 'That's gonna be a perty nice door, if what you're wantin' is a lot o' ventilation. But if you're wantin' a nice snug door to keep the winter wind out, let me show you a couple tricks here.' An' he rehung that door so snug a flea couldn't get in without an invitation. Heh, heh!

"An' another time we was tryin' to put in a window. He comes over, says, 'Boys, you cram that sash in like that, the pane's gonna crack the first time th' weather swells 'er up. Now I got just the right tool to trim that down to a better fit.' An' he worked on that thing I don't know how long, correctin' our mistakes. Gawd, he did a lotta work here, never mind he was already a-headin' home from a hard day. And he wouldn't take no money for it. We'd say, 'Come on, Frank, how much d'we owe ya?' And he'd say, 'Oh, a dollar nine twenty,' and then drive off home."

Sam nodded. It really was good to hear somebody say these things about his dad. The cafe owner chuckled and straightened up. He ran his fingers along the car door, and said, "So your pa's lettin' you use his car today, huh?"

"Yessir."

"Nice ol' car, ain't it?"

"Sure is, Pa says it's the most amazin' old car he ever saw."

"Yeah, you can tell he likes it. Heh, heh! Tell y' somethin', son, if you promise not to tell your pa."

"Uh, I guess." This made Sam a little uneasy. He wasn't sure he wanted to keep some stranger's secret from his own dad.

"Well, we-all wanted to repay Frank some way. Finally we saw how. While he was gone at work, why, now an' then we'd just drag this ol' car here into our garage, an' give 'er new plugs or a lube job or oil change, maybe top off th' gas tank, one thing or another. . . . Heh, heh. Now, boy, remember, don't tell 'im none o' this, 'cause knowin' him, he'd try to pay us for it, and we're already beholden to him. Okay?"

"I promise," Sam said with a big grin.

And away he drove in that amazing old car.

In a campfire conversation one cool evening the question was asked:

"Why do you suppose we were put on earth?"

The answer, from a conservationist in the group: "Well, obviously not to improve it!"

Agreed. Most of the works of man have been destructive.

But not all humanity's traces are odious. Some of our marks on the countryside are poignant and some arouse inspiration. I remember a poem in which Robert Frost spoke of finding a cord of firewood neatly cut and stacked and then apparently forgotten in a woods. He marveled at the unknown man who was so accustomed to hard work (in those days before chainsaws) that he could leave behind the product of so much effort. Maybe he went home and died.

I used to go up and down a farm road that went a quarter of a mile down a steep slope to an old farmhouse I owned. One of my neighbors was descended from the first owner of that house, and he told me how the road had been built and maintained. The man and his sons would take a wagon up into the woods to a ridge where sandstone chunks and boulders were exposed. With sledgehammers they would break those into spalls and throw them on the wagon, then drive down to the roadbed and set them in the ground to pave it. Good portions of it had to be repaved every year. If you've ever paved so much as a patio, you can imaging the work those boys did over and over again in that quarter of a mile. And that was in addition to their regular farm chores.

Here and there in the countryside—if you get out of your car and walk around—you'll find traces of men's strength and skill as it was back in the days before motorized machinery and power tools.

Look at the foundation stones of an old house—huge rectangular stones with the marks of the chisels and clourers still visible—and think of the manual work that made them.

Look at the hewn logs and dovetail joints of an old log cabin, or examine the mortised post-and-beam framework of an old barn, and imagine having to do such cutting and fitting with axes, saws, chisels, and augers—and your own muscle power.

Go to a state park, one of the older ones, like McCormick's Creek, and admire the stone stairs and shelterhouses and trails and the sturdy gatehouse, and think of the muscle power of all those boys who labored in the Civilian Conservation Corps during the Depression. Go look at the timbers of a covered bridge.

Walk an old farm and consider the long stretches of fence that were made and erected by hand—hand-cut posts, hand-dug holes, hand-stretched wire—before the machinery was invented to make such work easy.

Turn up a flint arrowhead along the bank of White River, palm it, and think of the Indian who made that so laboriously, centuries ago, by pressing tiny flakes of flint off with the point of an antler—hundreds of concentrated exertions of his powerful fingers to make a point that might well be lost the first time it was shot from a bow. . . .

There are traces everywhere, in the place where one lives, traces of man's skills and energy. You can see them when you're out close to the earth, and have time to reflect on them and be inspired.

It may be true that mostly what man has made is a big mess. But the individual man working with his mind and tools and physical strength usually had good intentions and a good heart while he was doing the work.

Go out and look at those faint traces of such honorable work, and you'll feel connected with others who had their roots where you have yours.

Stone arch at the pioneer village, Spring Mill State Park, Mitchell, Lawrence County.

Flowers and log cabin at the pioneer village, Spring Mill State Park,
Mitchell, Lawrence County.

As for those diverging roads Frost spoke of, and the many *what-ifs*, there were times when I could have traveled up various other roads than the storyteller's road. I might have lived in these hills just as happily if I had become a farmer or carpenter or stonecarver, or a forest ranger, which was my first serious intent. Or I might have been a professor at the university. For although most of this book is about the land and nature and rural folk, the university that sits here in the uplands has been a part of my being here, before I was born and ever since. Both of my parents were Indiana natives and Indiana University Medical School graduates. My mother could recall sitting in an establishment after classes and listening to a seemingly good-for-nothing law student named Hoagy Carmichael showing off at the piano. Like many IU students even today, my parents liked this part of the country well enough to stay here after graduation, thus giving me the good fortune to be born here.

When I escaped from Chicago, the IU Journalism School hired me as a part-time lecturer and the Bloomington newspaper as a part-time environmental writer, which

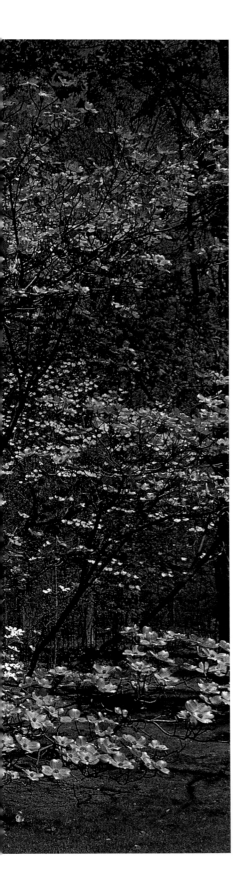

helped me support myself as a part-time freelancer until my books started paying my way.

The proximity of Indiana University enriched my life in other ways as I settled back into my homeland. Besides its traditional old-timers, this region harbors unorthodox and independent thinkers of every kind who have diffused into the social fabric from the university environs: the old locals have had to learn toleration and the newcomers have learned much of the old, solid wisdom.

As a music lover and art lover I can enjoy the best without having to drive more than twenty miles, and the cosmopolitan population of the university lays out a banquet of foods and cultures and literatures. And as a writer of Midwestern history, I could hardly have chanced into a better place for research. The immense university library, the Lilly Library nearby, and the resources of the various departments, from history and anthropology to geology and mapping, make freely available most of the facts I need for any book, while most special collections, as well as the historical sites and landscapes themselves, are within a few hundred miles in every direction.

I know craftsmen and cave-crawlers and farmers and truckers who never attended IU (I didn't, either) but are all the more content in these Hoosier hills where their roots are because of a university that has had its roots here since the days when Indiana was still the Land of the Indians and most Hoosiers were pioneers.

Bell Tower, Indiana University, Bloomington.

You really need a stout walking-stick here in the uplands.

It serves as more than just a cane. You can use it to brace yourself when you make your way down between the big mossy limestone outcrops in a ravine, or to spread the strands of barbed-wire as you duck through a fence. You can poke ahead with it in the summer in places where a copperhead might be loafing. At mushroom time you use it to probe through last year's dead leaves and uncover a succulent morel. In fall it can help you knock down just-ripe persimmons from the branches out of arm's reach. But a really special walking stick just simply becomes a walking companion, as familiar as, say, an old dog. A special walking stick leaning beside the door begs to be taken for a stroll on a nice day with as much wordless eloquence as an eager dog. Well, almost.

Take a look at this old walking-stick. It's a real handful. Substantial, like a shillelagh. What gives this old walking-stick its singular character is its corkscrew shape. Therein lies a story of three lives: a tree's, a vine's, and mine.

Across the road and northwest of my house there's a ravine with a sinkhole cave in the bottom of it. The cave is about the size of a small bedroom, and its entrance is only a couple of feet wide. I have to hunt around for it every time.

One day 25 years ago I had been checking out the cave, and as I crawled out, being at ground level, I saw something peculiar that made me stop, half out of the hole like some groundhog, for a careful look. It looked like a huge, coiled snake there amid the ground foliage, except that snakes don't stand on their heads.

I saw that it was the trunk of a maple sapling. To a standing man it would have looked just like another of the dozen or so maple saplings nearby. But a man at groundhog level looked at the strange, coiled shape of the trunk just above the ground.

In the grooves of those coils I found the rotted remains of a dead vine, and that told me the story.

A vine will find a small tree and start up it for support, winding around and around it. They stay together year after year, and as the tree grows, the bark and sapwood have to shape themselves to the coil of that tight, squeezing vine. Often the tree dies. This young maple somehow was an exception. It won. The vine lost, dying, while the maple continued to live, crippled with that deep, spiral scar, but healthy.

At that time I did not have a special walking-stick. I thought that tough little maple would make a one-of-a-kind walking stick, one with a story to tell.

I got out my belt hatchet and studied just where I'd have to cut. The knob at the very base where the roots came together would make the head of the cane.

Then I had a little moral crisis, there on my knees in a ravine with my hatchet in my hand.

What if I do cut this stalwart little tree down? I thought. In five seconds of chopping I could do what a vine had been unable to do in ten years: kill a heroic little sapling. Do I want to make it a walking stick with a story to tell, or leave it to live here unseen, its story untold, till it dies and falls and rots?

I know there are many timber cutters in these hills who would snort at my hesitation, those who cut down hundreds of magnificent hardwoods every year for the pallet factories and sawmills. But the fact is, I struggled with myself there. It wasn't as long a struggle as that between the tree and the vine, but it was as silent, and it shaped something in me just as surely as the other struggle had shaped the tree. There is a philosophical lesson at the very heart of anything that happens, in nature or in man. At the core of every *what-if* there is a moral, and no matter how small or inconsequential it might seem, you cheat yourself by ignoring it.

I almost didn't swing the hatchet, but finally I did, after making a vow to give that little tree at least as good a home as it could have had there in the ravine.

I shaved it down to the heartwood, sanded it, oiled and varnished it, and made it my companion, and I tell its brave little story to anybody who notices it. Many of its peer maples in that rocky ravine have since died and fallen. I take it back to that ravine now and then on my walks.

Or maybe I should say it takes me.

Living in a place involves looking skyward a lot, and thinking about what you see up there.

Watching the weather is a part of it, particularly for country folk who do so much of their important work outdoors.

But there's more to skywatching than just weather.

Most rural people are birdwatchers to some degree. We celebrate with uplifted heart the sight of a pair of red-tail hawks soaring and circling high over the valley, especially a pair we've been observing for years. "Well," we say, "glad to see their marriage is still working out."

Or we watch the echelon flights of migrating waterfowl in spring and fall. Lately we have seen an eagle, which for us is as thrilling as a Broadway opening is for a New Yorker. We hill people are easy to please.

And out here in the country the stars and moon are brilliant. We sit in meadows, out from under the canopy of trees, and our souls drink stars. And, being skywatchers, we get to see meteors and shooting stars.

Before Christmas 1993 my wife and I were out after midnight watching a lunar eclipse when we saw a brilliant meteorite go over and flash over the horizon to the east. In the Christmas spirit we decided to "follow that star." What it led us to was a tiny, starved, half-frozen lost white kitten that was all scratched from an owl attack or something and needed rescue. As we carried it home, my wife commented, "You're the first kitten in distress I ever saw send up a flare."

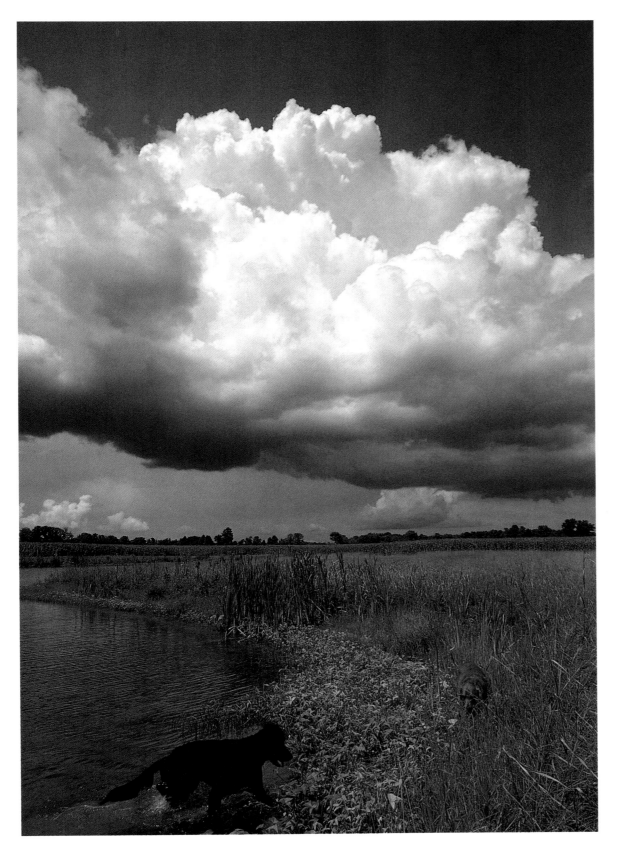

Cumulus clouds in summer, dogs playing in pond,
south of Patricksburg, Owen County.

When I was a boy watching these same skies from this same ridge, I never knew there would someday be straight white lines across the sky. Now there is rarely a time when the blue isn't marked by contrails from jet airliners. It's remarkable how we get used to things like that.

But still when I see one I imagine what one of the original people of this land would have thought and felt the first time she looked up and saw a white line clear across the sky. For tens of thousands of years nobody ever saw any such thing. It might have been taken for an omen, or a splitting of heaven. If it hadn't been explained to me, I might have thought the same thing.

My skywatching predominantly has been toward the west. As I said elsewhere in this book, I built my house here on this ridge because this had always been my sunset vista.

You can watch a sunset anywhere you go in the world, just to enjoy its beauty. But when you watch the sunset from where your roots are, it is more than just a sight. Your yesterdays and tomorrows are involved. The seasonal and daily cycles of your life are rolling around that center.

When I watch the sunset from this ridge my whole life's philosophy is limned by its light. With me are my memories of those who have watched the sunset here with me, as well as those long before, including the Delawares and the Shawnees and the Paleo-Indians even earlier. The sunset is the end of this day's daylight but it also presages the day to come and all the rest of the days to come, during which, God willing, I will be here in this same place, watching as usual. This is and has always been so pervasive in my way of living that when a Shawnee chief asked me to characterize myself so that he could give me a name in his tribe, I thought about it and told him that if there is any one thing I am it is a sunset-watcher, and so I was given the name that means He Sees the Sun Go Down. Now my wife, who is Shawnee, always watches it with me, and often carloads of regular sunset-watchers from the vicinity drive over and stop at the side of the road to enjoy this sunset view. Some of those people are so old I know they must have gotten started clear back when the old Quaker family presided over the sunset-watching here.

Studying and writing for 20 years about the white settlers' conquest of the "Land of the Indians," I've come to see the whole story in two simple geometric figures: a circle and a straight line.

The original Americans' way of life is represented by the circle: the rolling of the seasons, sunrise and sunset and sunrise again, birth and life and death and then the rising of new life, the circle of the horizons arced over and under by the circle from heaven through earth and the underworld and back up. . . .

This was an eternal, sacred roundness that characterized all life, including the animals who were your sisters and brothers. All this was a gift from the Creator who meant that it should always be so, and since you wanted your grandchildren and your grandchildren's grandchildren to enjoy the same sacred gifts you and your ancestors had, you would not think of changing the world. Therefore, what you took out of the Mother Earth you would put back in equal measure. That meant the ingredients of your physical self as well as the spiritual energy.

The Iroquois would begin every council with the admonition that every decision made there must be considered in terms of its effect on the next seven generations. The

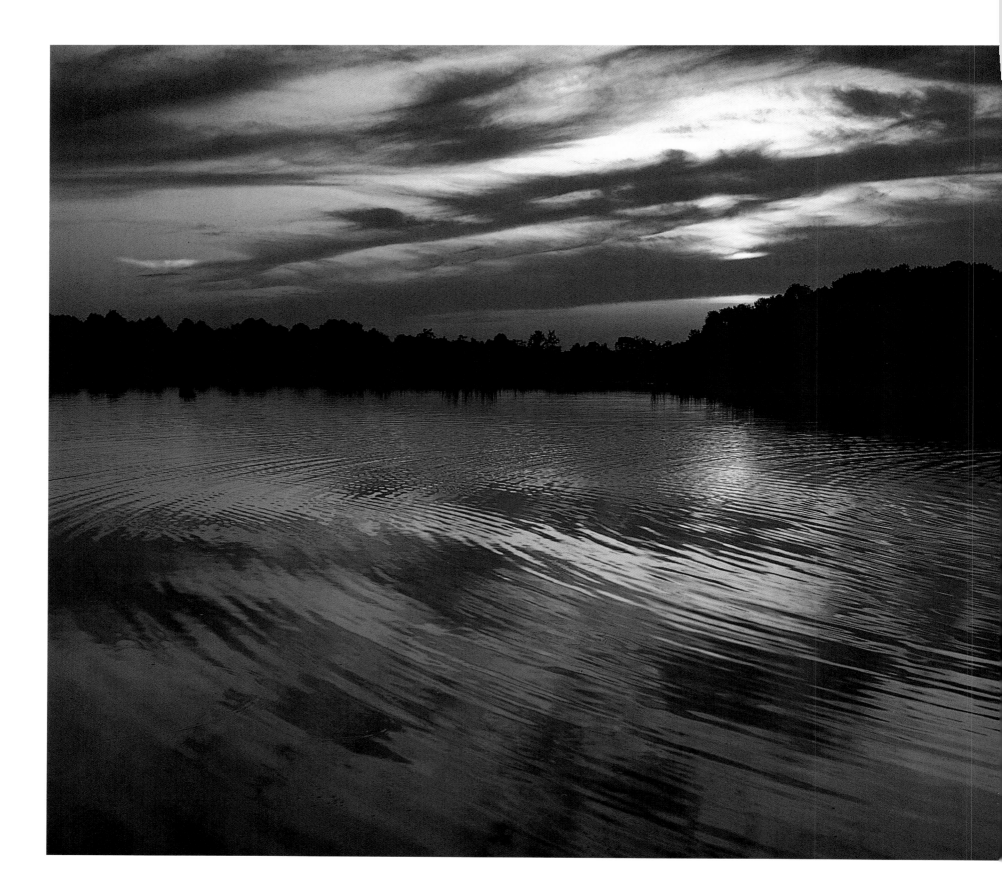

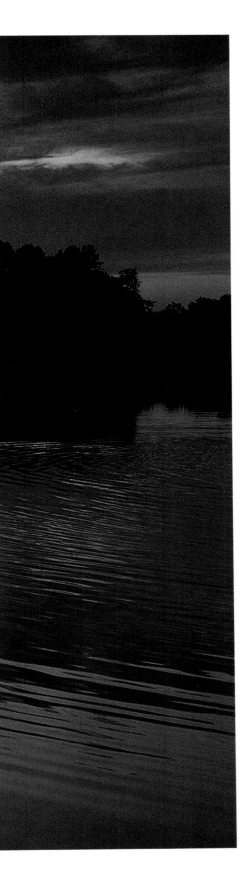

Algonquian hunters in killing an animal would make a prayer promise that in return for being fed by the animal's meat and clothed by its skin, they would in turn feed the animals of the prey's family and provide them shelter.

Then when the hunter grew old and died, he would be buried in a shallow grave with perhaps an acorn or a walnut on top. Then of course the oak or walnut tree that grew there fertilized by the hunter's body would feed and shelter the animals, who would in turn feed and clothe the hunter's children and grandchildren.

The immigrants who came after Columbus (my Shawnee wife refers to them as "the boat people") brought a life concept that was more like a straight line. They thought in terms of progress, from Point A to Point B, the result to be *change*, building from one thing toward a future thing which would be, according to their plan, better. They saw vast resources here and were appalled that the natives were not making full use of them. And so the white settlers' straight line of Progress thrust like an arrow through the native people's sacred circle, and nothing was ever the same again. The forests were all cut down and the earth was exhausted by farming and the buffalo and bear and wolves were killed off, and the Indians who weren't killed by guns or disease or whiskey were forced out of their homelands onto unfamiliar reservation grounds where they could not live according to the old sacred cycles they had maintained for tens of thousands of years. Where those reservations prove to have valuable mineral resources, the miners and drillers are still trying to get the Indians out of the way.

I once heard a Shawnee chief in Ohio explain to some visitors why his people had fought so hard in Tecumseh's time to keep the settlers from shoving them off their land.

"This ground we're sitting on as we talk," he said, pinching up some soil. "Our ancestors were here so long that this very earth is made of the flesh and bones they gave back to Mother Earth. We don't simply live on this land, we *are* this land."

Those words were the truest and deepest statement of the spirit of place. That is the very essence of *being here*. Truly being here is not merely occupying space with one's physical self. It is something sacred. Your sacred obligation to a place you call yours is *not to ruin it*.

Concentric circles in pond at sunset, private pond northwest of Freedom, Owen County.

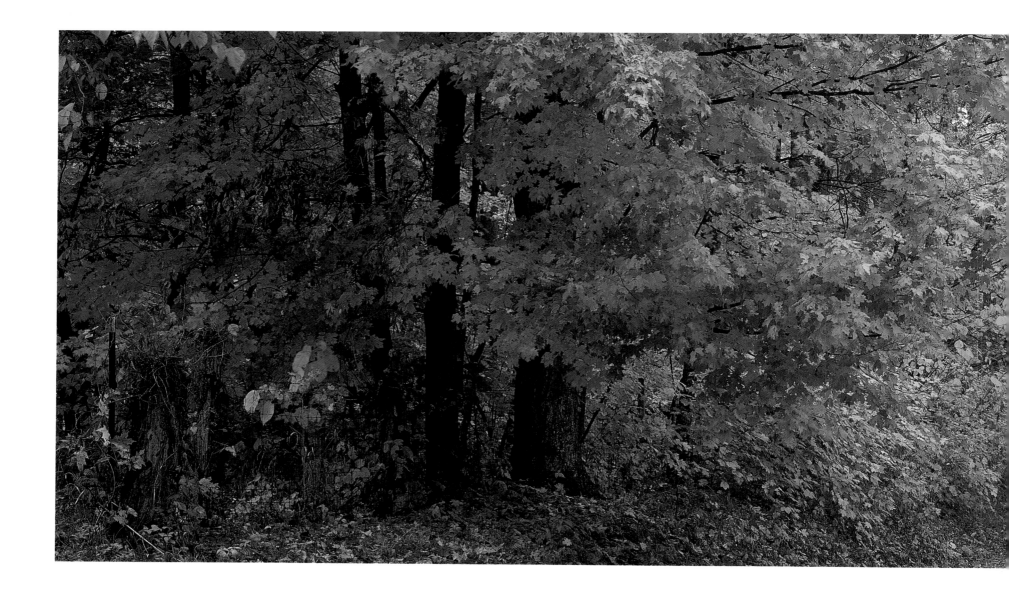

When my mother retired from medical practice early in the 1970s, my brother who is an architectural draftsman designed a cottage for her, to be built right where the old Macy house had stood. It was in fact built around the old fireplace and chimney of the old house, and much of the building material was salvaged from the old Macy house and barn. This was a kind of continuity. Another kind was the role of my mother as the "Sage of the Ridge," which had been Etta Macy's role through much of the earlier part of the century. Mrs. Macy had been a widely known interpreter of the poems of James

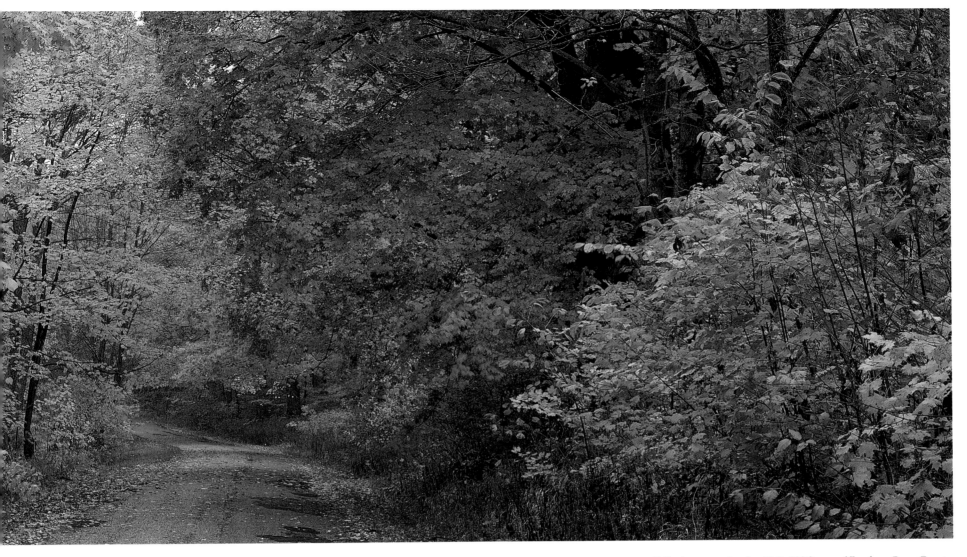

Fall colors on a rainy day, C.R. 600 S. east of Freedom, Owen County.

Whitcomb Riley, and people had come from all over the state to hear her recitations of Riley and other hill country verse.

Mother didn't recite Riley, but she offered the same kind of hospitality and food and sunset-watching, and, like Mrs. Macy, became a weaver and weaving teacher. She was also an organic gardener and a flower gardener. She became a leader of yoga and Eastern philosophy groups, thus perpetuating the peaceful, calm ways of the old Quakers here on the ridge.

Her home was also a magnet to her grandchildren, who came for advice and guidance, and to roam the ridge, which was rather like having one's own state park, with old Doctor Julia as the naturalist. One of her grandsons, my nephew Alen Clemons, particularly loved the area, and ranged over it like a beagle. He not only covered every inch of ground like a hunting dog following its nose, he also explored vertically. He was up in every tree and down in every cave. If anyone got to know this place as well as I had a generation earlier, it was he. If, in some sunny glade or on a rock hilltop you saw a little cairn of piled rocks, you could be sure that inside it there would be a faded note on a piece of scrap paper:

"A.C. WAS HERE."

When my mother passed over into the Spirit World in 1993 and a memorial service was held on her lawn under the shade tree, there were among the friends and neighbors many of the people who had come out to watch sunsets with her, and even some very old ones who had watched the sunsets with Etta Macy. Mother's ashes were in a walnut box one of my brothers had made. We all—family, friends, neighbors—dipped into the ashes and wandered out over the ridge to sprinkle her ashes in places on the ridge that had special memories for them. Some of the Stogsdill boys, whose family had been here for many generations, came down the road to the sunset overlook in front of my house, and scattered ashes there.

She has completed the cycle and is again a part of the earth in the place she loved. I guess it's my turn next, but I'm very healthy and have a lot to do yet. When my turn comes, though, I mean it to be here.

Snow scene at Green's Bluff Nature Preserve, Owen County

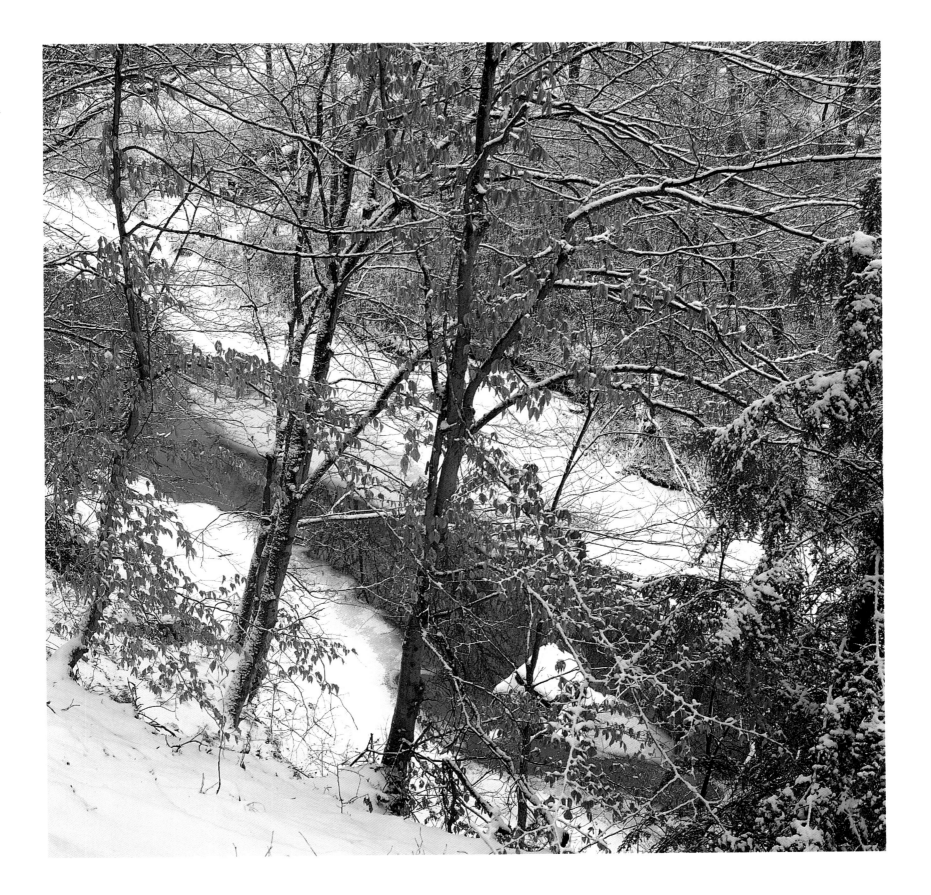

Darryl Jones has had numerous one-man shows in New York, Boston, Chicago, and Cleveland. His two previous books of photographs, *Indiana* (1984) and *Indianapolis* (1990), have been highly successful.

James Alexander Thom, a native of Owen County, Indiana, is the author of seven novels, including *Long Knife* (1979), *Follow the River* (1983), and *Panther in the Sky* (1989).

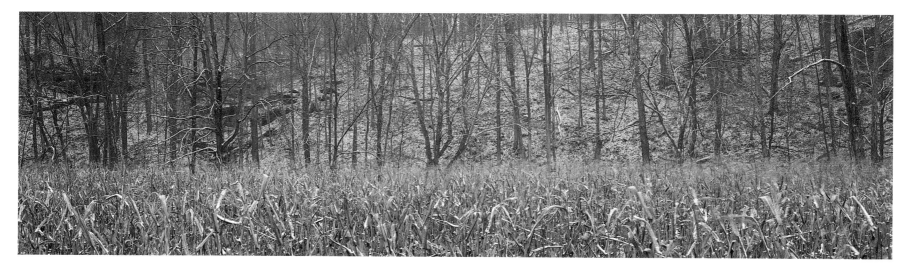

First snow of the winter, corn and hills, on Old Patricksburg Road near C.R. 475 W., Owen County.

BOOK AND JACKET DESIGNER: Sharon L. Sklar

EDITOR: Roberta L. Diehl

PRODUCTION COORDINATOR: zig zeigler

TYPEFACE: Goudy

COMPOSITOR: Sharon L. Sklar

PRINTER AND BINDER: Tien Wah Press